Hadrian's Wall
in our Time

Hadrian's Wall

in our Time

Edited by

David J. Breeze

Line drawings by Mark B. Richards

ARCHAEOPRESS ARCHAEOLOGY

Archaeopress Publishing Ltd
Summertown Pavilion
18-24 Middle Way
Summertown
Oxford OX2 7LG

www.archaeopress.com

ISBN 978-1-80327-734-9

Front cover. Mucklebank turret. Photograph Elizabeth M. Greene.
Although the photograph of Mucklebank turret was chosen because of its artistic merit, it reflects a historical moment in the study of Hadrian's Wall because it was excavated by John Pattison Gibson in 1892, the year that saw the death of John Collingwood Bruce the great interpreter of the frontier and the start of modern 'scientific' excavations on the Wall.
Back cover. The Wall at Walltown snaking round the rocky outcrops. Line drawing by Mark Richards.

This book is available direct from Archaeopress or from our website www.archaeopress.com

To the memory of a fallen tree in Sycamore Gap

Hadrian's Wall is a World Heritage Site

Contents

Individual Contributions

In the Beginning

Before the Wall

Hadrian and his Wall

Hadrian's Wall from East to West

A Note on Terminology

Hadrian's Wall has, over several centuries, acquired a language of its own. The very name of the Wall has changed over time. It appears to have been called the Picts' Wall in the medieval period. When scholars thought that the Wall had been built on the order of the Emperor Septimius Severus, it became known as Severus' Wall. In 1840, it was demonstrated that the Wall was actually built in the time of the Emperor Hadrian and so it became known as Hadrian's Wall. At the same time, it was often called The Roman Wall, and this phrase is still used in some circumstances, such as the title of the *Handbook to the Roman Wall*, the linear descendant of John Collingwood Bruce's *The Roman Wall*, first published in 1851, with its successor now in its 14th edition.

Behind the Wall, almost for its full length, is a great earthwork consisting of a ditch with mounds set back on each side, known as the Vallum since the time of the Venerable Bede who so named it in his *Ecclesiastical History of the English People*, completed in 731. Its principal feature is the central ditch, so it should really be known as the Fossa, but it is too late to change the name now.

The Wall itself was called the *vallum*. This word appears on the Ilam Pan (see pages 52-3). Along the top of the vessel are the words RIGORE VALI AELI DRACONIS followed by the names of four forts in the western sector of the Wall. Unfortunately, the phrase lacks punctuation, so we have to guess at that. It has been suggested VALI and AELI go together and demonstrate that the name of the frontier was the *Vallum Aelii*, the Wall of Aelius, Aelius being Hadrian's family name. However, RIGORE is a technical surveying term and an alternative view is that Draco, the man who owned and probably commissioned the vessel, was a surveyor and if so he would almost certainly have been a legionary and therefore had two names, Aelius Draco.

'Wall' refers not just to the stone wall which we see today, but its predecessor in the western 31 Roman miles (50 km) of the frontier which was originally built of turf. Its replacement in stone started in the reign of Hadrian and continued for some time.

The military structures along Wall have their own names: forts, milecastles and turrets. 'Fort' is a modern word; the Romans would probably have called a fort on the Wall, a *castellum* or *castra*, the derivations of our place names Caerleon, Lancaster, and of course Chester/Chesters, so it is not surprising that many forts along the Wall have Chesters in their name, including Halton Chesters and Great Chesters.

A milecastle was given its name by John Horsley in 1732 because these small forts, that is, 'castles', occurred at every mile. The word 'turret' was introduced into Wall terminology from the Latin word for a tower, *turris*.

Unfortunately, the complications do not end there. Along the Cumbrian coast, south-westwards from Bowness-on-Solway, are 'milecastles' and 'turrets' but here they are called milefortlets (fortlet = a small fort) and towers.

A confusion could easily arise between the names of the roads along the Wall. The Roman road is called the Military Way, while the Military Road is the name used for that constructed in the years after the Jacobite Uprising of 1745-6.

All dates are AD/CE unless otherwise specified.

Foreword

Rory Stewart

You are about to read essays by eighty farmers, walkers, photographers and archaeologists. One tenderly compares his teenage excavation of a guard's urinal to the uncovering of Tutankhamun's tomb. A second remembers a stumbling archaeological knight, losing his own vallum. A man, dedicated to preserving the grass sward of the Trail, precedes a woman who wants her children to be encouraged to clamber on the stones. Another evokes youthful disappointment.

Such essays blend what we half observe and half create. Memories are filtered through the feel of rain in toeless boots, the sound of curlews in May, and the scent of wild garlic. A Dutch scholar sympathises with a Batavian unit's request for beer; a Romanian scholar with the efforts of Dacian masons. Heaters, gloves and sleet are remembered; so is a mother-in-law walking. For me, formed by my time in military barracks in Iraq, I register the violence of the Wall and am drawn to Marta Alberti's lyricism: 'how striking, perhaps awe inspiring, perhaps dangerous, and obscene, must the curtain wall and all its apparatus have looked to those, whose ancestors had seen it in all its natural, unobstructed beauty.'

The great David Breeze, with Mark Richards the *genius* of this book, and perhaps the central figure in our contemporary understanding of the Wall, might be wary of my imperial analogies: would emphasize the Wall's limitations as a military barrier; might wish to dissolve the ethnic distinctions implied by units called after Dacians or Tigris boatman, and emphasise instead more local, less stridently distinct, identities within the *vicus*. But here, in these essays walkers, visitors, and pilgrims – inspired by the destruction of a tree much younger than the Wall - are released to imagine contradictory possibilities: set free from the epistemological anxieties of scholarship.

If I had been allowed a section in the book, for example, I would have written about the fort that once stood on the low mound, rising out of the wet, reed-fringed, sheep pasture at Bewcastle. A place near which my friend Steve keeps his British Blue cows, and Trevor Telford, his sheep: a place which has a problem with mobile signals, a primary school under threat, subsidies for forestry, and a 19th century joke about the absence of Armstrongs in the graveyard ('they were all hung as thieves in Carlisle').

Bewcastle fort was a poorly chosen spot, hard to supply, and hard to defend: with limited sightlines to the north; and the ridges to the south prevented direct signalling to reinforcements on the Wall. Little wonder that it was stormed and burned. The walls were constructed in a polyhedron, seen almost nowhere else in the Empire. The technical term for the unit shows it was double the strength of those in most other forts. Why did the Romans build and double garrison such an eccentric place?

The answer, I believe, lies in two words on an itinerary copied in a Byzantine world, and preserved in the Vatican, which tell us that the Romans called the fort, 'the shrine of Cocidius'. They built on the holy hill of an old Celtic God. A bent metal plaque depicting Cocidius has survived (he looks like a beetle complete with antennae); so too, has the inscription of a very grand visitor from Rome, who made the difficult journey to dedicate an altar there. The fort seems to have been located, not because of its strategic advantages, but despite its disadvantages, as a *temenos* or sacred enclosure, to keep the shrine of Cocidius and its divine power within the military frontier: as a way of colonizing a sanctuary, and controlling local worshippers: a tribute to fear of the sacred.

Perhaps some memory of this was even preserved, when an Anglian obelisk of assured craftsmanship and mysterious Christian meaning was driven like a stake into the heart of the site, three hundred years after the storeroom was burned. But these are not archaeological certainties. Perhaps the anomaly of the fort was simply some bureaucratic mishap, or a construction project authorized by a corrupt Imperial freedman. And the fort later merely a convenient quarry for the Anglian monastery.

Each of these eighty entries reminds us how difficult it is to interpret the twenty million stones, laid along the Wall. Al McCluskey, a former soldier, suggests the builders may have been too exhausted to invest much meaning in the blocks, which they passed from sweating hand to hand. Alex Croom reminds us how quickly sections were undermined by water and tumbled inwards. Jim Crow shows stones being relaid only a few decades after the first construction. Robert Witcher shows us 18th century engineers reusing the Wall as road foundation. Barbara Birley depicts Charlie Anderson moving the stones again with a digger in 1959.

Cut and moved, shoved and abandoned, cleared and repositioned by so many people over one and a half millennia, the stones might seem to shed all connection to human individuals: their tumbling, simply part of the more elusive geological history sketched by Ian Jackson. The rock's function as a wall becomes only a few moments in its hundreds of million years of existence: its emergence from the earth heart in lava, or

its formation in a stream bed; its encounter with the feet of dinosauromorphs, and ancestral crocodiles; its absorption of the concentrated carbon of the Triassic, and its long sojourn beneath the ice sheet.

But the attention which these writers have paid to the smallest engineering decisions of the Romans – to the precise turf they selected, their surveying lines, their bridges, and their sinuous dance with crag tops – revivifies the stones. And with them the roundabouts, reconstructions, quarries, tombstones, sponsored trails, visitor arches, pictures, maps, and virtual imagery spawned by the Wall. Through these essays and Pilgrimages, those who died and those who still work in the shadow of the Wall find a joyful, ingenious, scholarly, ironic, ever-evolving memorial: reanimating the mute and resistant masonry.

Overleaf: *Anchored*
monotype by
Rebecca Vincent, 2023

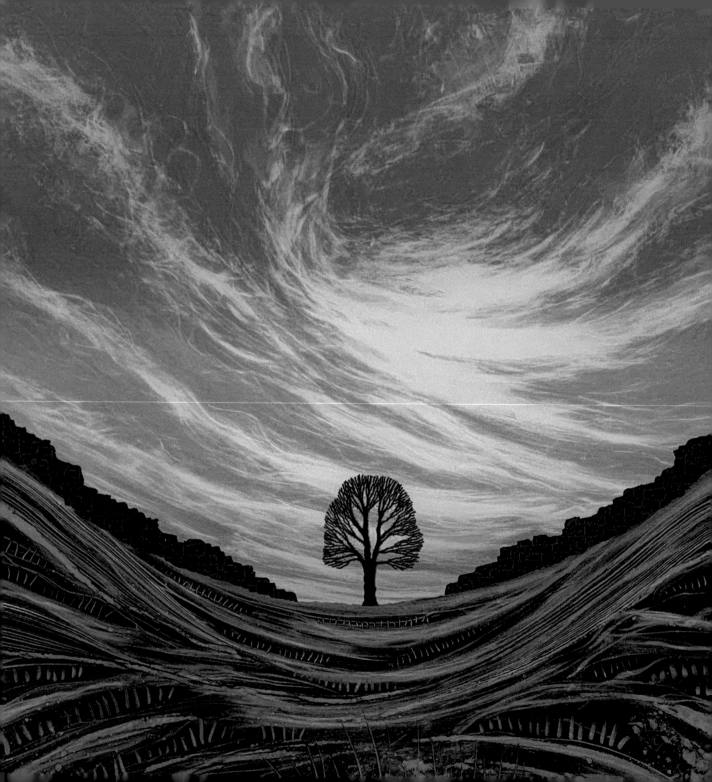

Introduction

The cutting down of the tree in Sycamore Gap, made famous by the film *Robin Hood, Prince of Thieves* starring Kevin Costner and Morgan Freeman, on the night of 27/28 September 2023 was a shock. The loss of this iconic tree on Hadrian's Wall reverberated across Britain and beyond. Social media, the air waves and newspapers all covered the story. Suggestions for the future of the remains of the tree, whether in the ground or now removed from the site, have poured into the National Trust, the owners of the ground, and Northumberland National Park, guardians of the wider area.

In this book, Jim Crow, who excavated the Wall hereabouts, tells the story of Sycamore Gap and its tree. The contributors to this book describe other iconic views of Hadrian's Wall popular to visitors and authors alike over the last 200 years. We hope that this will provide some comfort to those grieving for the lost tree, for history teaches us that new iconic views of Hadrian's Wall will come to the fore. With that in mind, I invited colleagues and friends who have excavated on the Wall, written about it, worked on it, taken groups there or simply visited the Wall, to offer their favourite view of Hadrian's Wall and why it is special to them. The net has been cast widely, with contributors from America and Canada and several continental countries as well as the UK. When it comes to the contents, we have not restricted ourselves to the structural remains, nor to only the Roman remains, nor to only the Wall itself. The discovery of two massive stone heads by Frank Giecco and his team excavating the newly found building in Carlisle is a reminder that individual objects can become icons in their own right. So can paintings, drawings, photographic records of excavations, and even the excavators themselves. All are represented here.

The idea for this book emerged in the days following the cutting down of the tree. Jim Crow wrote to the *Times* about the history of the tree. Carly Hilts, editor of the popular archaeological magazine *Current Archaeology*, was considering how to deal with the issue when I wrote to offer a short article on the event looking at earlier iconic views of the frontier. In discussion with Mark Richards, this quickly grew into the realisation that many colleagues had a favourite view of the Wall. On 9 October, I approached Archaeopress with a proposition for a book of these favourite views, and this was accepted. So, on 10 October I issued an email inviting about 40 colleagues to write about 200 words, supported by an illustration, about their favourite place on Hadrian's Wall; twenty-four hours later I had over 30 acceptances! What was particularly impressive was that only one view was chosen by more than one contributor. The contributors' various responses are a resounding indication of the appreciation, indeed love, that archaeologists have for Hadrian's Wall. It is hard not to conclude that it is the whole of the frontier that has their affection and not just one part of it.

In a way, that is reflected in the status of Hadrian's Wall as a World Heritage Site, which incidentally includes several places not actually on the line of the Wall including South Shields, Bewcastle, the forts, fortlets and towers on the Cumbrian Coast and Ravenglass with its amazing bathhouse. Inscribed in 1987, it was one of the earliest properties in the UK to become a World Heritage Site, an acknowledgement of its importance as an archaeological site, not just in this country but on a world-wide scale. As part of the process of nominating a property as a World Heritage Site, the support of the local community has to be demonstrated. It can fairly be said that the views of several elements of the Wall community are clearly expressed in this book.

What this book does not do is to offer a coherent view of the building and history of Hadrian's Wall. Nevertheless, through reading and linking the individual contributions the story of the Wall is told as well as something of the history of its exploration, a fascinating subject in its own right. Shining through are the memories of the Wall offered by 80 archaeologists and colleagues who have known and explored Hadrian's Wall over the last 70 years. They have helped broaden our understanding of this magnificent ancient monument, but fear not there is still much more to be learnt about Rome's most celebrated surviving structure in Britain.

The title for this evocation was suggested by Mark Richards and for that, and for his superb line drawings, I am most grateful. I also owe thanks to the many colleagues and institutions who kindly provided the other illustrations for this book: they are listed in the acknowledgements.

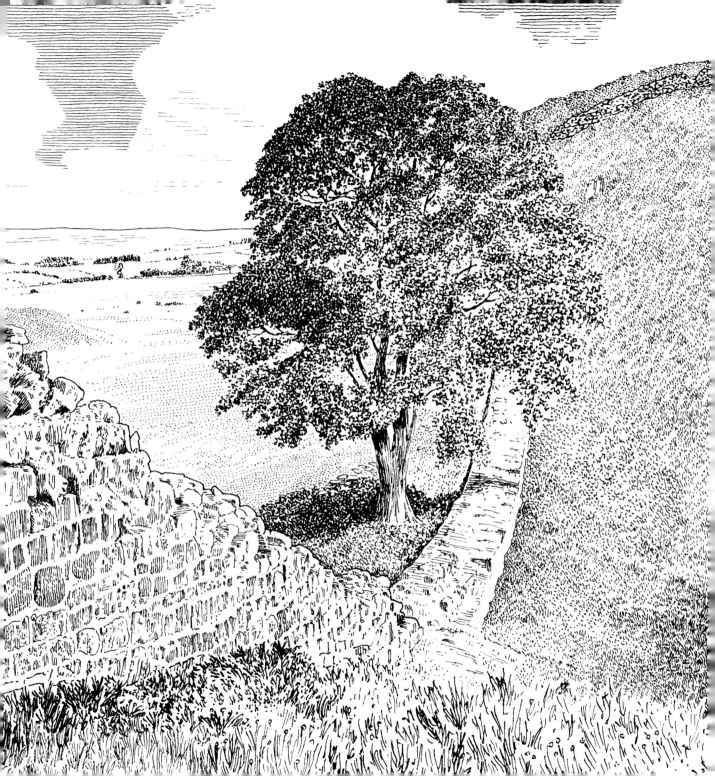

The Tale of a Tree: Sycamore Gap on Hadrian's Wall

Jim Crow

For many visitors to Hadrian's Wall the first sight of the now-vandalised tree in Sycamore Gap was from the Military Road, silhouetted in the long crest of the Whin Sill. A matching gap to the west, Castle Nick, is the site of milecastle 39 and between the gaps the prominent but lower hill known to archaeologists as Mons Fabricius, named after a visiting German frontier specialist in 1929. From there the Wall makes a precipitous descent into Sycamore Gap, where it contains one of the highest standing lengths of the Wall, before climbing east towards Highshields Crag. Excavations of Hadrian's Wall in the 1980s commenced on each side of milecastle 39, and in 1983 heading east we began the steep descent to the Sycamore tree and the Wall on the north side of the tree. Buried deeper than expected, the Wall stood eight courses above its whinstone foundations. Of especial interest were the finds of worked stones including a roughly carved window head and later 2nd century pottery, evidence for the repair of Hadrian Wall after the withdrawal from Scotland about 160.

Mons Fabricius from the Military Road flanked by Castle Nick and Sycamore Gap

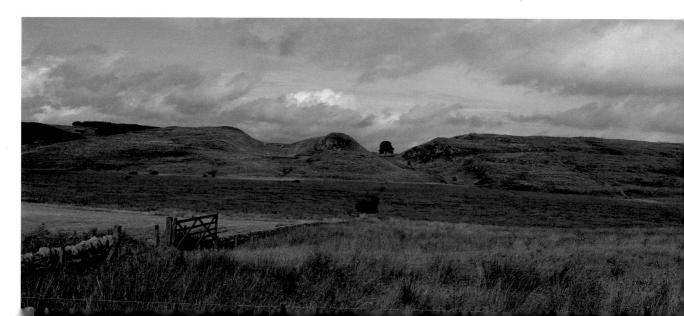

John Hodgson's record of Sycamore Gap in 1832

The north face at Sycamore Gap had never been excavated before, but parts of the high standing Wall climbing to the east had remained uncovered since Roman times. The earliest record of this length appears in the unpublished journals of the great Northumbrian historian John Hodgson (1779-1845) now in Northumberland Archives. An entry dated 18 October 1832 (Vol. Z, p. 402) shows the profile of the gap with a stone enclosure and the outline of a tree, the first representation of the sycamore. The enclosure was constructed to preserve the tree from grazing cattle or sheep and appears on the first six-inch Ordnance Survey map of 1860. The date in Hodgson's notebook gives a *terminus ante quem* for the sycamore, but when was it planted? Some recent newspaper reports have suggested under King George I (1714-27), a century before Hodgson's sketch, but future dendrochronological dating may yield greater precision.

In practice, we can narrow the date of the planting of the tree down by considering the radical landscape changes to the central sector and its farms during the second half of the 18th century. Two significant events need to be considered. First, the construction of the new Newcastle to Carlisle turnpike or Military Road financed by local landowners in the 1750s. This road ran over the north edge of the Vallum and lay only 530 m south of Sycamore Gap. The road opened up this remote district and the indomitable Wall walker, William Hutton, found a bed at the old Twice Brewed Inn amongst a crowd of hungry carters in 1801. The second major change was the enclosure of Henshaw Township in 1787. The enclosure map defines the pattern of regular stone walls, often set at right angles to the Military Road seen today. North and south of Sycamore Gap the fields are marked as belonging to John Lowes Esquire. Hodgson's evidence of a relatively immature Sycamore within a stone enclosure, suggests that the tree was planted at the time of the enclosures as a landmark between John Lowes' fields south of the Wall and the open ground on the north side running along to Steel Rigg farm, now the site of the Northumberland National Park car park. The Northumberland landowner John Clayton, whose stewardship secured much of the Wall and forts in the central sector, purchased Steel Rigg farm including Castle Nick and Sycamore Gap in 1834.

A pollen core from the west end of Crag Lough 120 m north-west of Sycamore Gap, revealed a cleared landscape dating from late Neolithic period, about 2500 BC. Cereal pollen is attested from the Bronze Age and later in the Iron Age. Clearance continued into the Roman period probably for grazing with limited re-afforestation after the Romans. The key evidence for the medieval period survives around Mons Fabricius, where shielings, single room stone huts, were built for seasonal grazing or transhumance. This phase of pastoralism ended in the 17th century when the first farmsteads at Steel Rigg and Bradley were established. Overall survey and environmental data reveal a pastoral and farmed landscape, largely cleared of trees since the later Neolithic period over 4000 years ago. It would seem that the sycamore was not a relic of an ancient woodland as has been claimed, instead we suggest that it was planted as a landmark, to be seen from the new road. Celebrity came via Hollywood and Kevin Costner and Morgan Freeman in 1991, and for a later generation the tree in its gap was voted Tree of the Year in 2016, becoming an active and much-loved symbol of the natural world; tragically now a stump it became a victim to human frustration and anger.

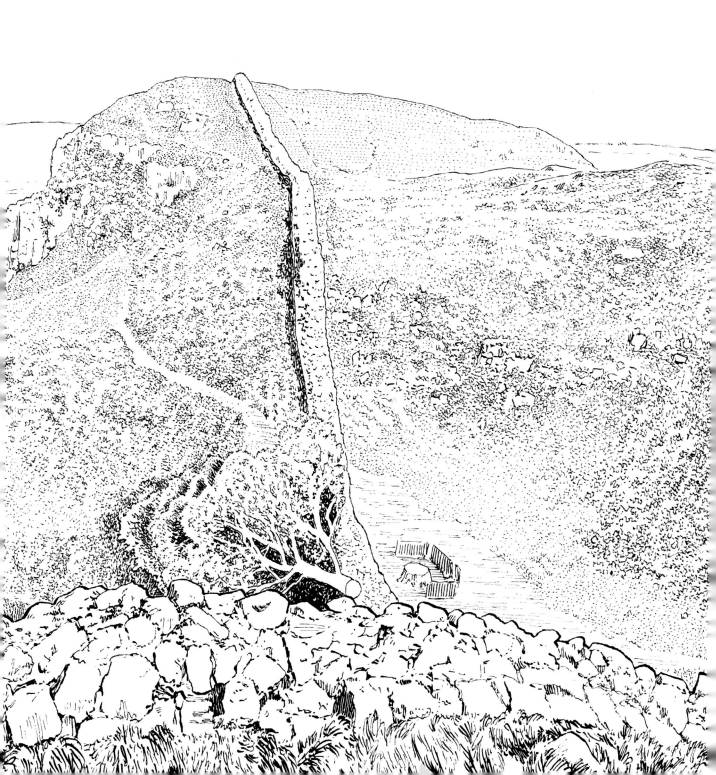

The Iconic Landscapes of Hadrian's Wall

David Breeze

In the second half of the 19th century, the iconic view of Hadrian's Wall was of Walltown, then generally known as Carvoran Crags, a little to the east of the Roman Army Museum at Carvoran. John Hodgson, author of a *History of Northumberland*, included in his fourth volume published in 1840, a long footnote on Hadrian's Wall illustrated by drawings specially prepared by William Collard and showing the surviving state of the Wall in the Walltown area. It was, however, the stimulus provided by John Collingwood Bruce (1805-92), the great doyen of Hadrian's Wall in the second half of that century which led to the creation of several paintings and drawings of Walltown.

In 1848, Bruce, a schoolmaster in Newcastle, undertook a tour of Hadrian's Wall with his son Gainsford, the two drawing masters at his school, Charles and Henry Burdon Richardson, and his groom, William. Four dozen drawings of the Wall were prepared by Henry and given a colour wash over the following winter. The drawings by the two brothers were published in *Hadrian's Wall: Paintings of the Richardson Family* by the editor of this book in 2016. In the painting to the right, Bruce is recognisable bottom left with his top hat. Gainsford, later an MP and High Court Judge, sits on the rock to the right. On the northern lip of the ditch stand three figures. The front man has a satchel; he is likely to be Henry. Behind him in a broad brimmed hat is perhaps his brother Charles, while the figure at the rear is presumably William, the groom.

The members of John Collingwood Bruce's 1848 expedition to Hadrian's Wall at Limestone Corner.

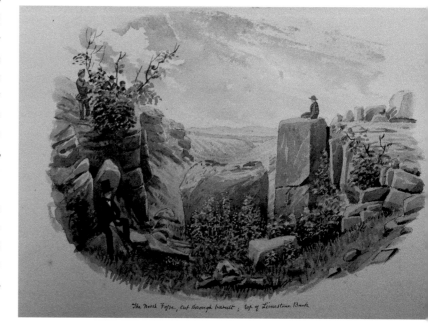

The North Fosse, cut through basalt; top of Limestone Bank.

'The Wall as it is seen going eastward over the Nine Nicks of Thirlwall' by Henry Burden Richardson, drawn in 1848

Bruce used many of these paintings, re-created as engravings or woodcuts, in his book on Hadrian's Wall published three years later with the lugubrious title, *The Roman Wall, A historical, topographical, and descriptive account of the barrier of the lower isthmus, extending from the Tyne to the Solway, deduced from numerous personal surveys.* This was the first of six books on Hadrian's Wall that Bruce was to write and revise over the following 34 years. For reasons we do not know, Bruce decided not to include an engraving of Walltown, but turned Henry Burdon Richardson's painting into a woodcut. Bruce used John Storey, another Newcastle painter, to create the engravings, and although we cannot be sure, it is likely that it was Storey who produced the woodcut of Walltown at Bruce's request.

The view of Walltown portrayed in the woodcut is recognisable today, with the rock to the right, the Wall following a twisting path as it crosses the landscape, and the peak of Mucklebank Crag in the background. What is also visible is the tongue of land to the left – in the shade – which was later quarried away.

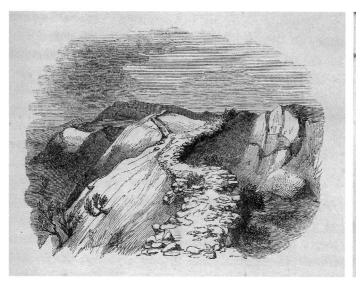

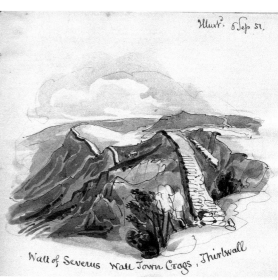

Wall of Severus Wall Town Crags, Thirlwall

Walltown attracted artists over the following years. In 1851, this stretch of Wall was drawn by an anonymous visitor, who created several views of the area. In spite of intensive investigations, we have still been unable to identify the visitor.

In 1884 John Collingwood Bruce published the second edition of his *Hand-book to the Roman Wall*. In this he included a new engraving of Walltown Crags by Charles J. Spence, one of several commissioned by Bruce for this edition of his now-famous guide.

Our final painter is David Mossman. Born in Edinburgh, Mossman created several paintings of Hadrian's Wall. In 1893 he donated his watercolour of Walltown to Tullie House Museum and Art Gallery in Carlisle.

These are but a selection of the depictions of Walltown Crags created in the 19th century. It is interesting to compare them with each other, and with the Wall today. Some, including Mossman, exaggerate the landscape features. Nevertheless, all relate more or less approximately to today's Wall. Walltown, however, fell out of favour with artists when quarrying started in 1876, continuing for a full hundred years until 1976 when workable reserves of the stone were exhausted. By this time, the number of the Nicks of Thirlwall had been reduced from nine to six.

Left: Woodcut of Walltown, probably by John Storey

Right: Walltown drawn by an anonymous visitor in 1851

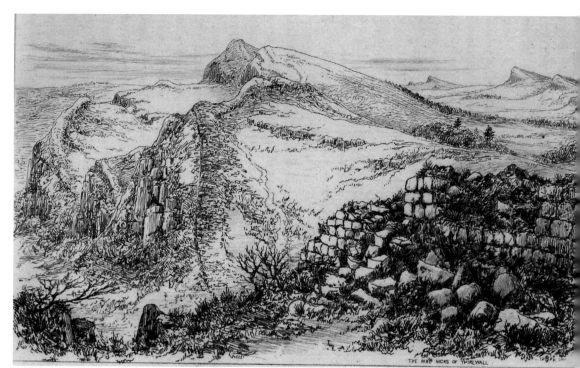

Walltown by Charles J. Spence

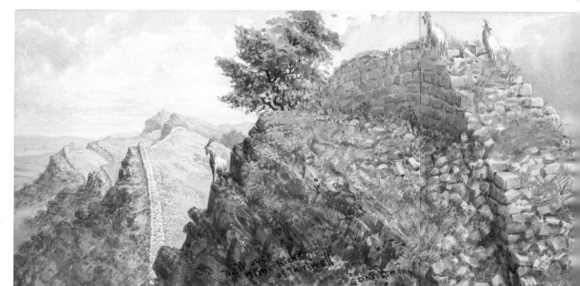

David Mossman's depiction of Walltown

Nevertheless, in spite of the quarrying the remaining crags at Walltown offered such an impressive landscape that in 1959 Alan Sorrell chose this view to be the basis of his own artist's impression of Hadrian's Wall. Sorrell, however, created his view of the frontier line as he could see it, not knowing, or perhaps accepting, that a chunk of it had been quarried away, that tongue of land visible on the 19th century paintings. This omission does nothing to detract from the drama of Sorrell's iconic impression. It is also no surprise that his children, Julia and Mark, chose this image for the cover of their book on their father, *Alan Sorrell. The Man who Created Roman Britain*, in 2017.

Alan Sorrell's impression of Hadrian's Wall soon after its completion

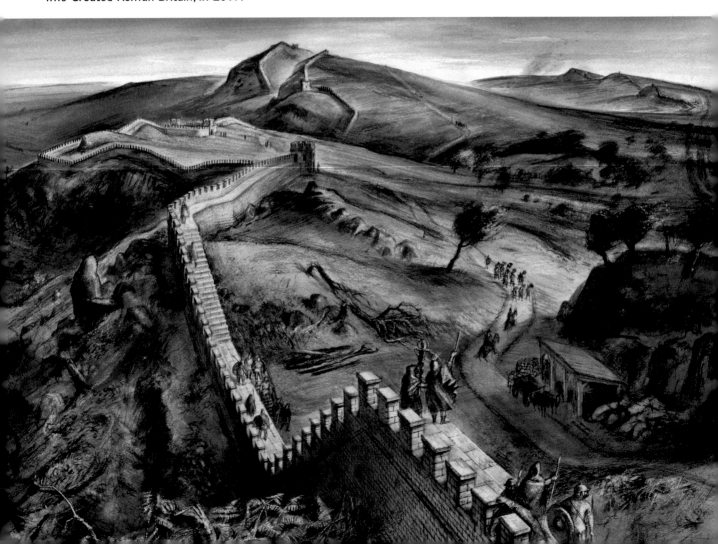

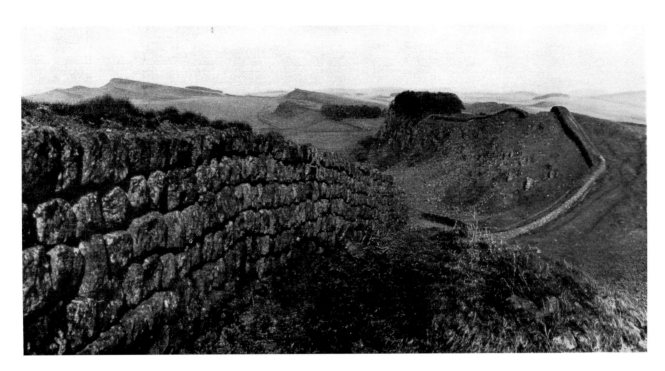

John Pattison Gibson's photograph of Cuddy's Crag

Cuddy's Crag

The section of Hadrian's Wall which took over from Walltown Crags as the iconic view was that of Cuddy's Crag. This view is not one painted by Henry Burdon Richardson in 1848, though he painted the crags from the opposite direction with Crag Lough more visible. Bruce only mentions the crag in passing in his magisterial third edition of *The Roman Wall*, published in 1867. In the ninth edition of the *Handbook to the Roman Wall,* R. G. Collingwood used a photograph of Cuddy's Crag by the famous local photographer John Pattison Gibson as his Frontispiece. And there it remained up to Ian Richmond's twelfth edition of the *Handbook*, published in 1966.

This new iconic view was the delight of artists such as Geoffrey Cowton of Bradford, who created an attractive image of the crags. It was not just an act of pietas which led Mark Richards, Peter Savin and myself to place Mark's pen-and-ink drawing of Cuddy's Crag on the cover of our *Hadrian's Wall: A Journey through Time,* but a genuine appreciation of this as one of the Wall's iconic views.

Overleaf: Cuddy's Crag by Mark Richards

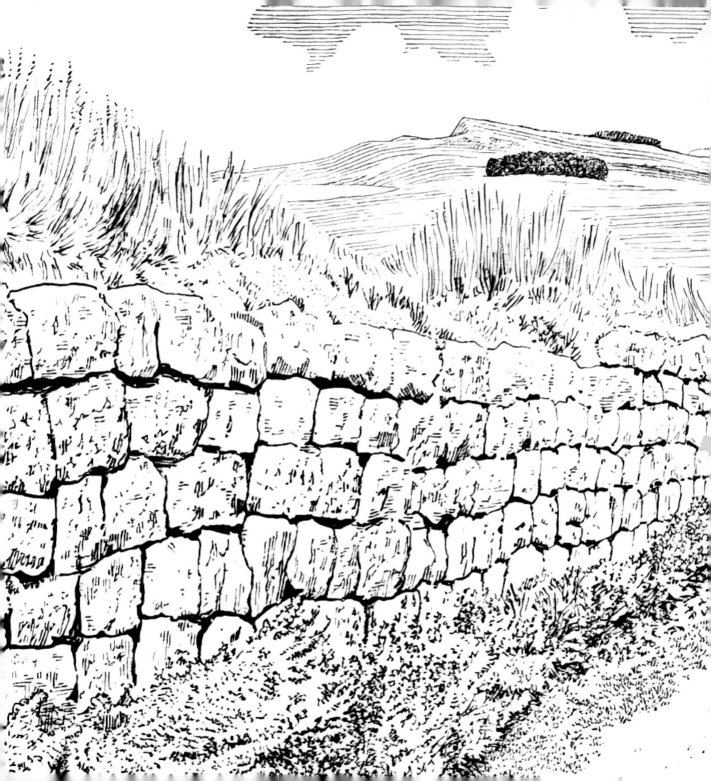

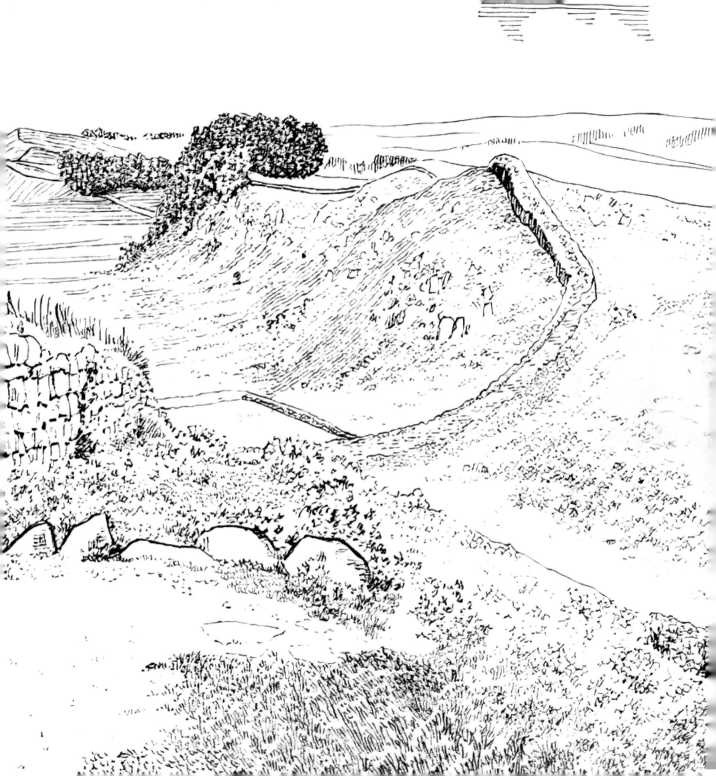

Limestone Corner

John Collingwood Bruce and his party visited Limestone Corner in 1848 and Henry Burdon Richardson created several paintings of both the ditch and the Vallum to the south. Besides writing the authoritative guide-book to Hadrian's Wall in 1851, Bruce also organised what became known as the First Pilgrimage of Hadrian's Wall in 1849 for the members of the Society of Antiquaries of Newcastle. The second was not held until 1886, but thereafter, war permitting, they have been held every ten years, especially following the Centenary Pilgrimage of 1949. One of the traditions which grew up around these events was the meeting of the Presidents of the two organising societies, the Society of Antiquaries of Newcastle upon Tyne and the Cumberland and Westmorland Antiquarian and Archaeological Society. Unfortunately, the photograph of the two Presidents, Katherine Hodgson and Thomas Romans in 1949, lacks the lustre of the 1848 paintings.

Limestone Corner looking west by Henry Burdon Richardson in 1848

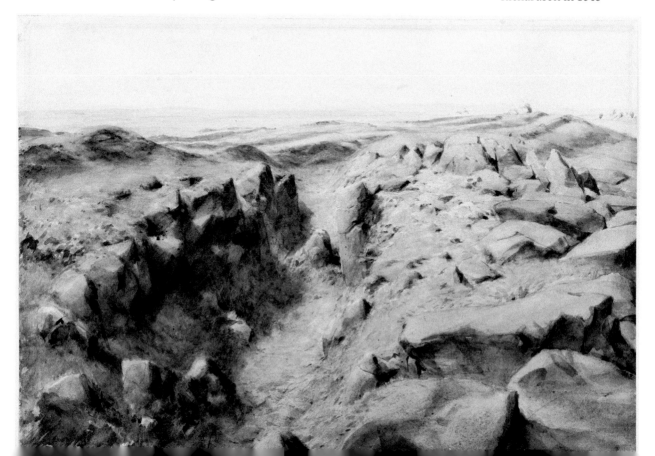

Thomas Romans and Kate Hodgson in 1949

Denton, Newcastle upon Tyne

On the western outskirts of Newcastle upon Tyne sits a short stretch of Hadrian's Wall at Denton. This has the distinction of being the first stretch of Wall to be seen on a journey westwards from Newcastle. It is carefully consolidated, but is now bare. Once an apple tree stood on this fragment of the Wall. It was first recorded by William Hutton, who walked from Birmingham to the Wall, along its whole length and home again in 1801. He published a slightly fanciful view of the tree. He was followed by the artist Thomas Miles Richardson Senior in 1823 and his son Henry Burdon Richardson in 1848. The tree was damaged in a gale in 1833 and again in October 1853. John Collingwood Bruce recorded that the damaged trunk fell in 1861.

In 1845, however, the Rev. Bigge had taken a cutting from the tree and when he moved to Stamfordham two years later he took it with him. He described the apples as small, good to smell but not so good to eat. I recently tracked down an old tree in the former Vicarage Garden at Stamfordham. The apples were described as small and rather scabby. The National Fruit Centre at Brogdale was unable to

identify the apples which suggests that their tree is of some antiquity, though the present tree may be descended from a pip of its 19th century predecessor.

Fashions change. It was the appearance of the tree in Sycamore Gap in a popular film which led to its rise to be *the* iconic view of Hadrian's Wall of our times. But the earlier iconic images of Rome's famous frontier have not been forgotten. In 2019, the organisers of the Pilgrimage of Hadrian's Wall chose a modern painting of Walltown Crags by Judith Yarrow to mark the event.

Judith Yarrow's painting shows the visual reality of today. Artists offering their impressions of the Wall in the past could be more relaxed. Some reconstruction drawings are fantastical, not least the representation of the Wall in the late 4th century by H.R. Millar in Rudyard Kipling's book, *Puck of Pook's Hill*, though few can beat the imagination of the artist who placed a 'light rampart chariot' racing along the top of Hadrian's Wall.

Nor should we forget the iconic stories and poems about Hadrian's Wall. One of the most famous is Rudyard Kipling's *Puck of Pook's Hill*. Written in 1906, it contains the story of Parnesius, centurion of the Thirtieth Legion, and his time on Hadrian's Wall. Perhaps the most iconic poem amongst the many written about Hadrian's Wall is W. H. Auden's *The Roman Wall Blues*, published in 1937, cited by Harry van Enckvort (page 26) below. It follows in a long tradition stretching back to Sir Walter Scott's *To a Lady - with flowers from the Roman Wall*:

Left: The apple tree on Hadrian's Wall at Denton as recorded by William Hutton in 1801

Right: The apple tree drawn by Thomas Miles Richardson in 1823

Facing top: Henry Burdon Richardson's 1848 painting of the apple tree

Facing bottom: Walltown by Judith Yarrow 2009

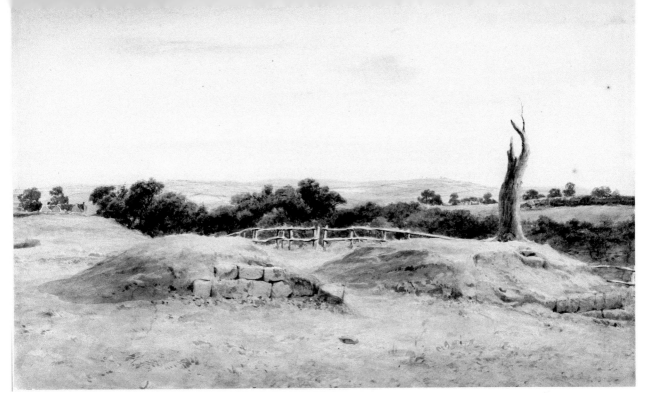

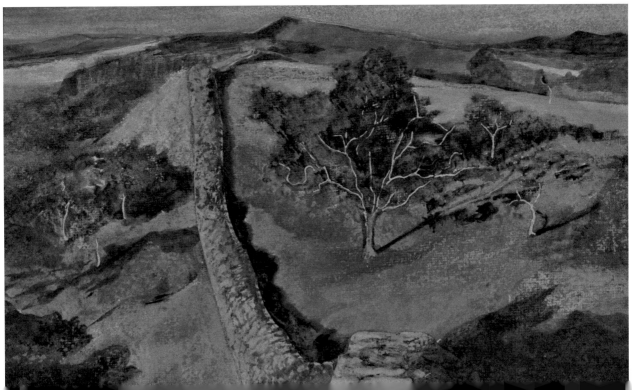

Take these flowers which purple waving,
On the ruin'd ramparts grew,
Where, the sons of freedom braving,
Rome's imperial Standards flew.

The lady in question was Charlotte Carpenter who Scott met and courted at Gilsland and married in Carlisle Cathedral in 1797.

A little over a hundred years later, in 1912, Frederick Palmer wrote *An Ode to the Roman Camp at Chesters, Northumberland*:

O proud Cilurnum, city of the past!
Where are thy legions in their fierce array?
No More, no more the martial trumpet blast
May summons thy plumed cohorts to the fray.

Yet the ruins of *Cilurnum* - modern Chesters – survive to this day and the fort is one of the most iconic – and popular - sites on Hadrian's Wall. One person who was inspired by his visit to Hadrian's Wall was George R.R. Martin whose visit in 1981 led to his wall of ice in *A Game of Thrones*.

H. R. Millar's depiction of Hadrian's Wall

Young Marvelman on Hadrian's Wall
(Vol 2 No 129, week ending 4 Feb 1956)

Facing: Professor Eckhard Deschler-Erb and his students from Cologne University at the tree on 24 September 2023

Individual Contributions

In the Beginning

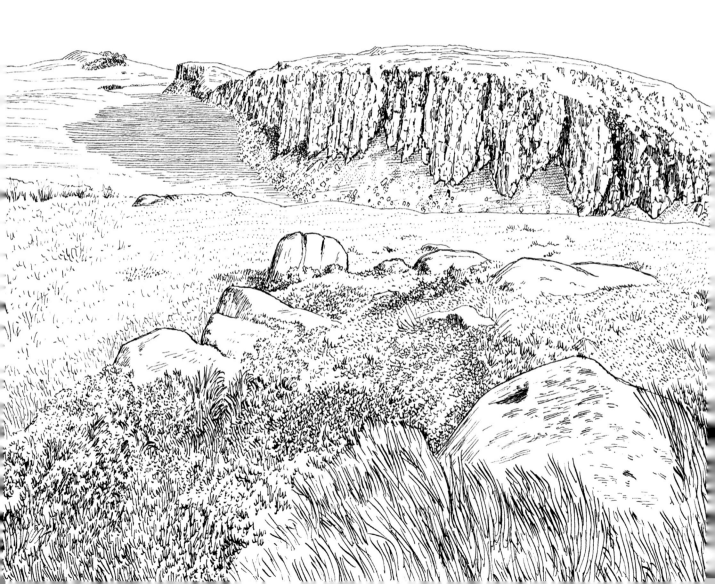

Hadrian's Wall and Sky

Catherine Teitz

It is a long journey to reach the Wall, whether for a soldier across the Empire or a PhD student from California. There are boats, car(t)s, trains, and planes, all ending with a climb from the Tyne valley to the summit of the Whin Sill. The climb of that first hill is my favourite; as I finished my dissertation at Vindolanda, it reminded me every morning of why I was writing.

First ascending gradually from Bardon Mill, briefly dipping into Chainley Burn, and steeply through Westwood, the bulk of the hill and the curve of the road keep the Wall from sight. The Tyne valley stretches below, inviting a pause to look back with every step, a sit on a well-placed bench, and a blackberry plucked in summertime. Then up the nearly vertical slope, treacherous in winter, through a tunnel of trees, round one more bend, and the whole landscape of the frontier unfolds. Vindolanda's walls and a patchwork of fields fill the foreground, and the Wall draws a line between earth and sky along the ridgetop. The Wall stretches east and west, simultaneously a monumental imposition and a natural extension of the topography. Yet with the sky open in every direction, the frontier is not one of limits, but of boundless possibilities.

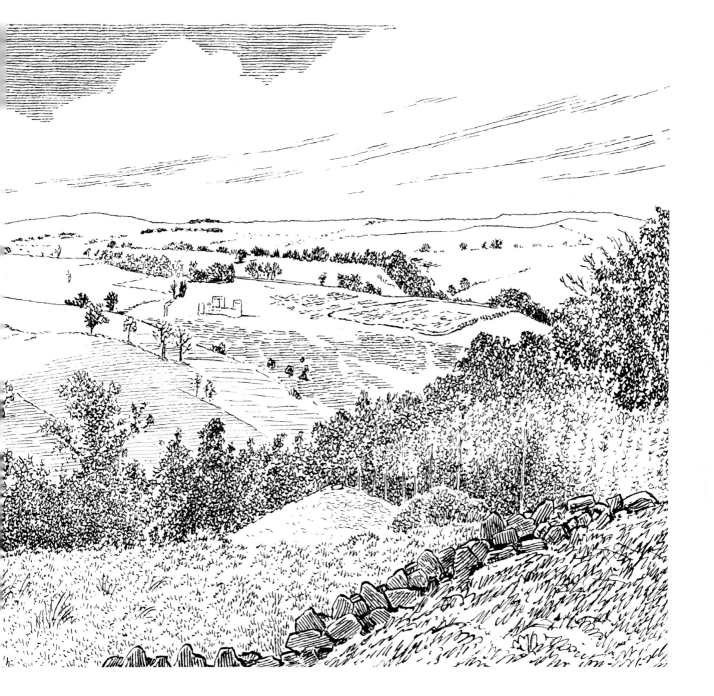

The Landscape Tells Stories

Harry van Enckevort

The Roman army planned its borders in a variety of landscapes: mountain ridges, deserts and rivers. In Britain the alignment of Hadrian's Wall west of Housesteads took advantage of the strategic opportunities offered by the Whin Sill.

On the other side of the North Sea, the Rhine provided a suitable barrier to protect the Empire. On the strategically located 'mountains' near Nijmegen, the Roman army built the first legionary camp in 19 BC. From this glacial outwash plain, 40-60 m above sea level, the Roman legionaries had a good view of the Batavian settlements on the river plain. Centuries later, Hendrik Marsman (1936, translated by Paul Vincent) wrote of this landscape: 'Thinking of Holland / I see wide-flowing rivers / slowly traversing / infinite plains...'. Almost 120 years after the founding of Nijmegen, Batavian soldiers were sent from their homeland to the far north of Britannia to guard Hadrian's Wall. The rugged landscape bore little resemblance to the Rhine delta, although the weather must have been similar if W.H. Auden (1937) in his poem *Roman Wall Blues* is to be believed: 'Over the heather the wet wind blows, I've lice in my tunic and a cold in my nose. The rain comes pattering out of the sky…' The Batavian soldiers stationed on the British frontier will have gained many new impressions there but they also clung to old traditions as evidenced by the letter found in Vindolanda from Masclus of the Eighth Cohort of Batavians asking his commander to send beer. After years of service, some Batavian veterans returned to the Rhine delta and Nijmegen with wives, children and souvenirs. As an archaeologist in Nijmegen, I am curious about the connected Roman frontiers in the Dutch river area and northern England. During my Pilgrimages to Hadrian's Wall, I was struck by the stories of the soldiers who lived near the Wall and the landscape in which they worked. Over a pint in the evening, they became more and more exciting.

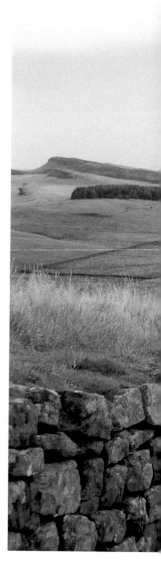

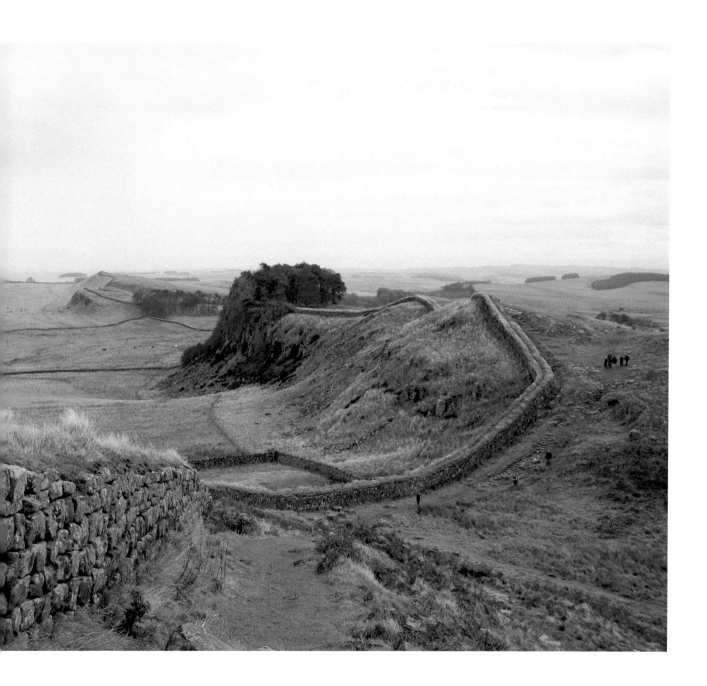

The Red Rock Fault

Ian Jackson

A single line on a map can be very important, especially if it is on the definitive geological map. Geology helps explain the location and structure of Hadrian's Wall. One such line is the Red Rock Fault. Archaeologists believe it runs north-south across the Wall just 5 miles (8 km) from the east end of the Turf Wall. They have placed great significance on this line, suggesting that it explains why the west end of the Wall is red and not grey-brown and why here it was initially built of turf, arguing there was no limestone for mortar available to its west.

I will whisper this but those of a nervous disposition best be seated. There is no Red Rock Fault dividing red from grey-brown. Almost 100 years ago, it was recognised, not as a tectonic dislocation, but a sedimentary feature known as an unconformity. It is where younger rocks overlap older, in this case where the red sedimentary Permo-Triassic rocks encroached eastwards onto the eroded surface of the grey and brown rocks of the Carboniferous. Not that you can see much of the change on the surface; all that multi-million-year old bedrock is covered by very thick glacial and alluvial clay and sand less than 20,000 years old.

So, how do we know where the line is? We don't precisely. We have to interpret, interpolate and extrapolate from inadequate exposures in stream beds, rare water well records, boreholes, geophysics – and stone buildings such as Hadrian's Wall and Lanercost Priory (illustrated). So, when you next admire the beautiful colours and lines on a geological map, you may be comforted to know that they are every bit as much an interpretation of the available data as an archaeological monograph.

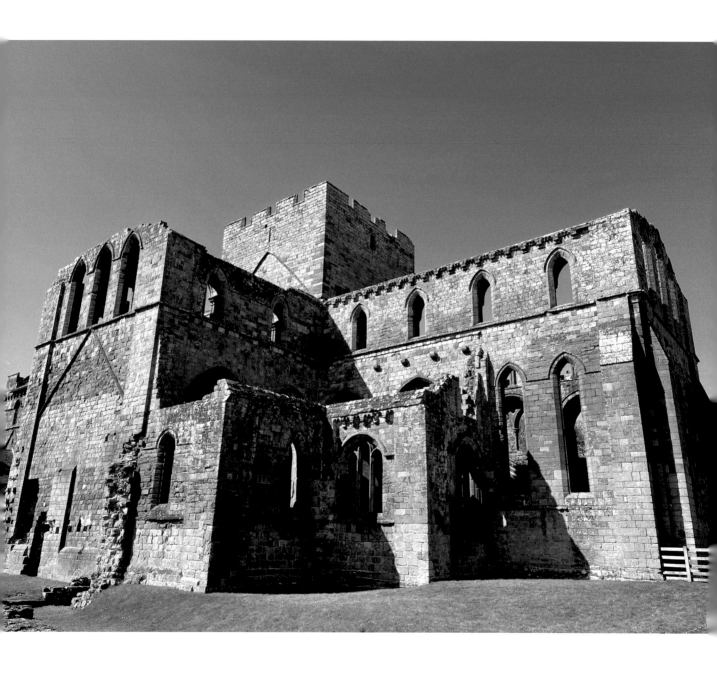

Before the Wall

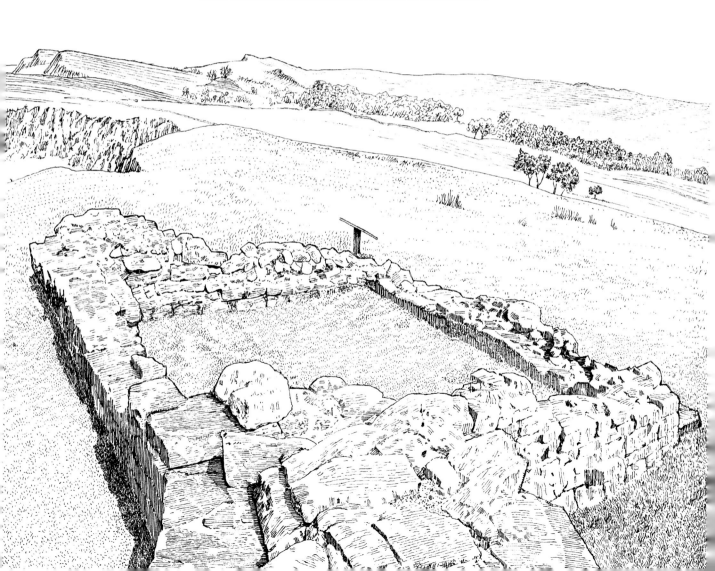

Wark Forest

Marta Alberti

It was a bright blue day of August 2021, and I had been working as an archaeologist at the Vindolanda Trust for seven years, when I finally settled on my favourite part of Hadrian's Wall. I could have just as easily picked my place of work, on a quiet summer evening, when the excavations are over for the day and the birds swoop down to catch the worms we've disturbed. Or perhaps the dramatic dip the Wall takes, on a wet walk from the Samson Inn, heading towards Birdoswald across the river Irthing, as I am followed by a flock of volunteers eager to learn more about this incredible archaeological treasure trove of information.

Instead, I picked a view of the Wall from beyond its impressive boundaries, looking back from the marshes and moorlands between the curtain and Wark Forest. While the landscape beyond the Wall has been heavily exploited and modified since the abandonment of Britain as a Roman province, this view still incites reflection. As we focus on further understanding the archaeology of each site, and of the World Heritage Site as a complex, we can sometimes forget about its social and emotive history. We know that the garrisons manning the Wall entertained relationships, sometimes cordial, sometimes businesslike, sometimes neither, with the people living beyond the frontier. How wild must this world have looked to the Roman soldier who walked the same path as I did, beyond the walls of the milecastles and into moorlands and forests. How striking, perhaps awe inspiring, perhaps dangerous, and obscene, must the curtain wall and all its apparatus have looked to those whose ancestors had seen it in all its natural, unobstructed beauty.

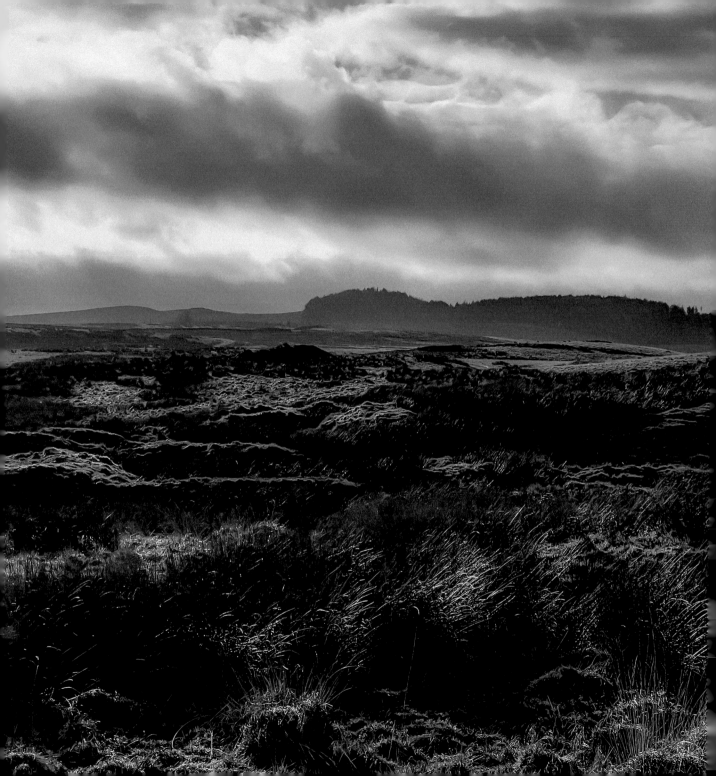

Milecastle 39 (Castle Nick) and Crag Lough

Avril Sinclair

Approach this view of the Northumbrian landscape from Steel Rigg carpark and it is breathtaking. There are three complementary aspects: the geology, the lough and the Wall. The primary feature is the natural underlying geology that has created the dramatic edge of the doloritic Whin Sill, dipping north to south, and is seen striding off into the distance. This provides a natural defensive location for Hadrian's Wall, following the edge of the Whin Sill. The Wall is particularly well preserved and spectacular from this viewpoint. Gazing down below there is an excellent view of the well-preserved milecastle 39 (Castle Nick). Its internal walls inspire thoughts on what it would have looked like when complete and in use.

In the distance, resting almost against the base of the Sill is the natural freshwater lake of Crag Lough. Apparently, the origins of this date back to early post-glacial times when this area was inundated by melt-water lakes. The landscape along the edge of the Whin Sill is challenging, with steep sections requiring steps to be cut into the crag to aid the walker. The gaps in the crags have resulted from the erosive power of post-glacial meltwater streams, probably exploiting weaknesses such as faults, creating the low points in the Sill. The geology of this part of the Wall has therefore led to the formation of two signal features, the Whin Sill as a useful line for the Wall, and two dips, one to hold a milecastle and the other a tree.

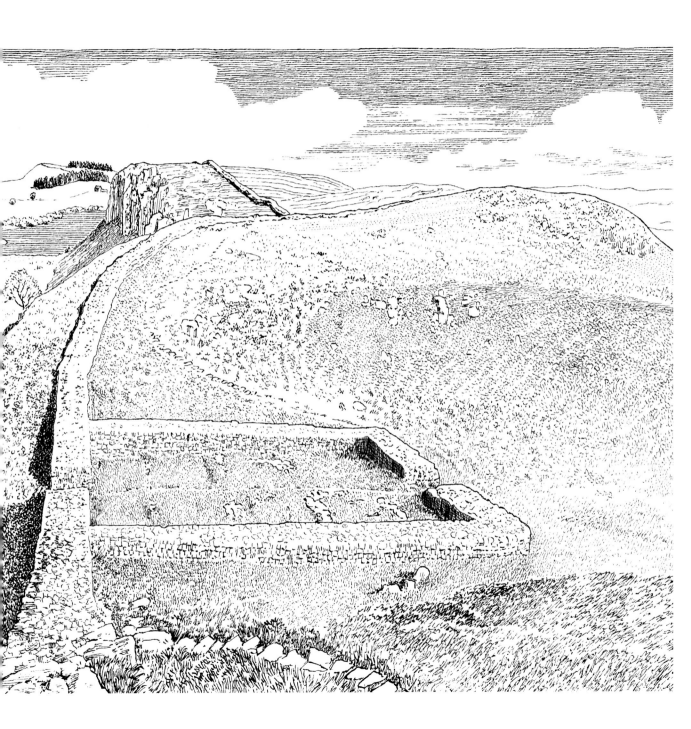

Milking Gap

Lesley Macinnes

Less than a mile to the east of Sycamore Gap another glacial channel cuts through the Whin Sill that supports the most visually impressive sections of Hadrian's Wall. Here, mid-way between the Wall and the Vallum, sits the sheltered Iron Age settlement known as Milking Gap. Excavations in 1937 revealed this to be a typical farmstead, with structural evidence of expansion over time. Like many such sites, its dating is insecure, relying on the presence of Roman material, but it seems to have been occupied into the early-mid 2nd century.

This rough stone-walled enclosure (visible centre) may be less prepossessing than the Wall in whose shadow it lies, but its remains are nevertheless evocative and remind us that the Romans did not build their frontier in a vacuum, but rather on land that had been occupied and farmed for millennia. The settlement at Milking Gap seems to have survived the initial military occupation of the area and we don't know exactly when it came to an end, though recent work north of Hadrian's Wall suggests the possibility of widespread clearance of the local population from the frontier zone around the time the Wall was constructed.

Milking Gap is now a tranquil place, but it is also an intriguing and poignant reminder of the indigenous inhabitants on whom Hadrian's Wall must have had an impact. Perhaps those at Milking Gap initially thrived under the *Pax Romana*, only to find eventually that, as Calgacus reportedly claimed (Tacitus, *Agricola* 30), the Romans 'make a desert and call it peace'.

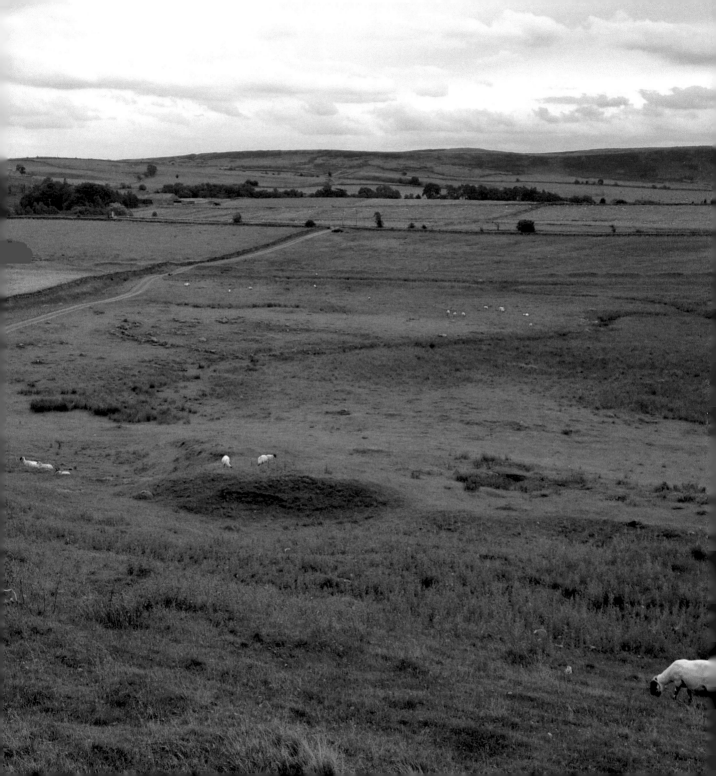

Haltwhistle Burn

Rebecca H. Jones

As a student at Newcastle University in the late 1980s, I was fortunate to go to various stretches of Hadrian's Wall on numerous occasions. In my various student homes, I lived not far from the Benwell Roman temple. But in my final year studies and subsequent career, it was the land to the north that drew me, and the campaigns of the Roman army in northern Britain.

Amongst the most spectacular remains of the campaigns of the Roman army near Hadrian's Wall are the collection on Haltwhistle Common. Fairly subtle earthworks now, of several camps and a fortlet, one of the best ways to visualise them is from the air, where their scale and location next to a spectacular stretch of the Wall, Vallum and milecastle 42 at Cawfields Quarry can be appreciated. Some of the camps along this central section of the Wall would have housed soldiers engaged in its surveying and construction; others would have been for forces on the move prior to the Wall being built and later manoeuvres and campaigns.

During the 2009 Pilgrimage of Hadrian's Wall, Humphrey Welfare led a breakaway group of four of us to walk around the camps, and it was a fantastic opportunity to have that discussion of them with the person who had led on their interpretation. Ten years later, we got camps onto the Pilgrimage's radar and Humphrey and I gave the pilgrims a tour of Burnhead camp, just to the north of the Wall at Haltwhistle. Whilst perennially the bridesmaid, it is good to think that camps can get their 15 minutes of fame!

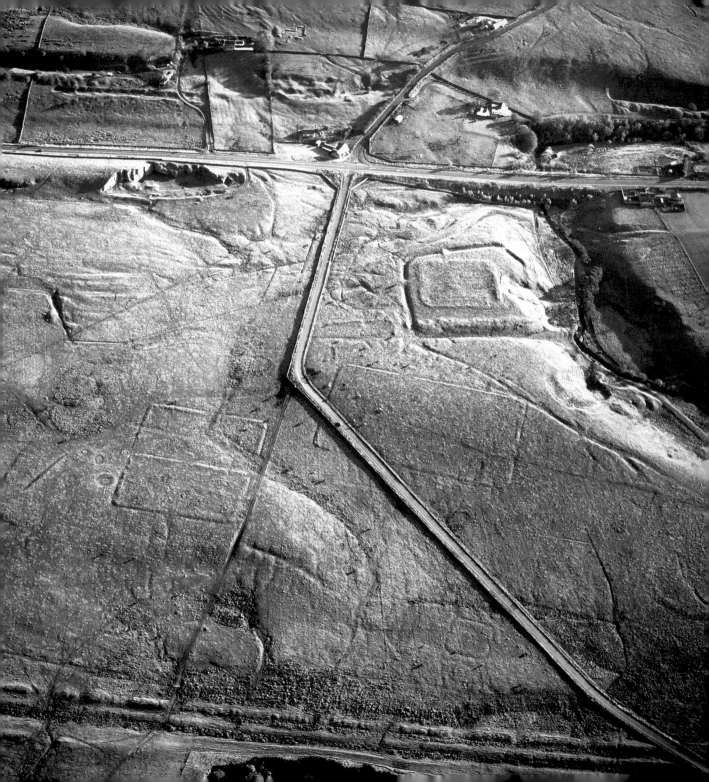

Vindolanda and the Stanegate

Alexander Meyer

The view from Barcombe Hill looking west over the Vindolanda fort plateau is one of my favorites. From this elevated site you can see thousands of years of history, from the Iron Age settlement at the top of the hill behind you, through the Roman period and on to modern coal works and the Robin Birley Excavation Centre. I love to see the ancient Roman road, known as the Stanegate since the medieval period, as it cuts a straight line through the countryside from Corbridge in the east to Carlisle in the west, providing a clear reminder of the affect humans have had on the natural world. A Roman milestone stands in the valley just out of frame in the bottom right corner and another lies near the copse of trees before the T-junction in the background. Of course, you can also see the line of Hadrian's Wall on the hills in the top right corner. This view reminds me of how much we have accomplished along Hadrian's Wall in the 22 years I have been involved. In 2002, only the central range of the fort at Vindolanda had been exposed and far less of the civil settlement (*vicus*) had been thoroughly explored. The current aspect of Vindolanda is the result of the work of hundreds of volunteers and a wonderful, dedicated staff.

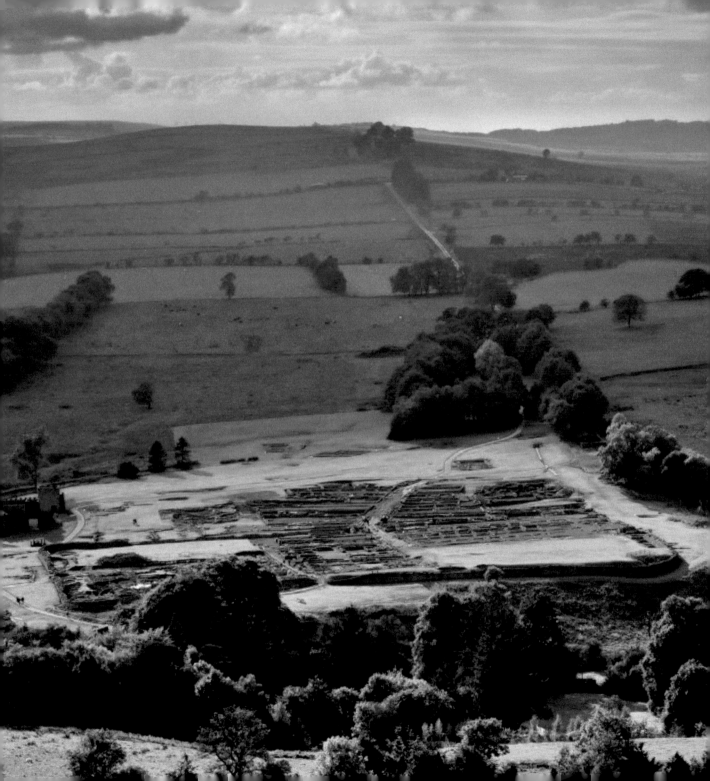

Rudchester and the Planning of Hadrian's Wall

John Poulter

My favourite view of or from Hadrian's Wall is one which partially obscures the line of the Wall itself. It can be enjoyed from the layby on the B6318 road, which stands almost in the middle of where Rudchester fort came to be sited. When investigating the planning of the line of Hadrian's Wall I had reached Rudchester and felt immediately that it offered an outstanding viewpoint of the landscape ahead, sloping gently southwards towards the River Tyne from which the planners of the Wall – working westwards from Newcastle – would have sensed an opportunity to set out a new long-distance alignment for the Wall

But there were two problems. The first was that the view of the line of the Wall in the distance was obscured by high trees. Hence, I couldn't check the Wall's alignment without hiring a double-decker bus! The second was that instead of changing direction at this (to me) obvious location, the line of the Wall continued straight on downwards to Eppies Hill, and only there did it turn south-westwards, as indicated on this annotated Google Earth view.

This oddity continued to puzzle me before a renewed examination of the map revealed that the Roman planners had indeed set out a new alignment from Rudchester, but that they had also set out two deviations from it, the first to Eppies Hill, the second to Harlow Hill. Both deviations appeared to have been laid out in order to secure the best view to the north whilst retaining a view to the south, an important observation relating to the purpose of the Wall.

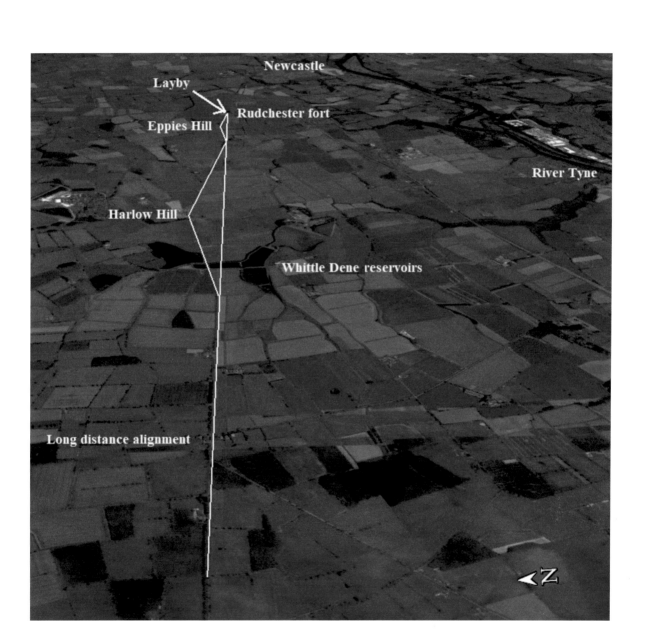

Coombe Crag

Kathleen O'Donnell

Just a few hundred metres east of turret 51b (Lea Hill), through a patch of woodland, and down a meandering path, you will find one of the many hidden gems of Hadrian's Wall. Coombe Crag is one of many building stone quarries which supplied the construction of Hadrian's Wall, and still bears the marks of the quarrymen on its surface today. I first visited the quarry in spring, while the smell of wild garlic was lingering, and the low sun filtered through the Scots pine casting dappled light across the steep path downwards. The path through the quarry is flanked on each side by a steep drop to the meandering River Irthing below. Like most of the quarries of the Wall, it is memorable for its somewhat dangerous beauty.

Several inscriptions are carved above a ledge projecting from the quarries face, mostly recording the names of unknown soldiers with unpractised hands. Historically, this quarry was often overlooked in favour of the more famous Gelt quarries. John Hodgson's statement from 1820 is indicative: 'We have not thought it necessary to notice the rude letters carved upon the Coombe Crag, which more probably were meant to commemorate a mechanic or a peasant than an emperor.' (Hodgson, History of Northumberland 1820, 55).

However, in additional to its significant natural beaty, Coombe Crag and its inscriptions provide a unique insight into the social history of the Wall's construction. These inscriptions include the names of people who worked at the quarry face as opposed to merely naming their supervisors or the reigning consuls. To me, this quarry provides a glimpse into the enormity of the task confronting the builders of the Wall, and the collaborative endeavour required to accomplish it.

Hadrian and his Wall

A Coin of Hadrian

Richard Brickstock

When I was ten, my grandfather presented me with a penny minted in 1897, the year of his birth. It was worn but brightly burnished (for he had buffed it up with Brasso) – and I have it still, worn though no longer shiny, since no self-respecting numismatist would dream of polishing a coin! It shows the aged Victoria, Queen-Empress of an Empire even greater than that of the Romans and, on the other side, the helmeted figure of *Britannia*, sitting proud and straight on a pile of armour.

In 1970 I had no idea that an almost identical image of *Britannia* had first appeared on a coin some 1850 years earlier, in the reign of the Emperor Hadrian. Fourteen years later, as a newly-appointed member of staff at Durham, I catalogued my first '*Britannia*', of Antoninus Pius, from Piercebridge, minted in 143-44 and therefore quite reasonably to be linked with the Romans' northward advance and the construction of the Antonine Wall.

The illustrated coin is, however, the very first to bear the *Britannia* design, a copper *as* which, judging by its limited circulation, was intended solely for the British market. I would like to be able to associate it with the building of Hadrian's Wall, begun in 122 – but its reverse legend places it earlier, in the period from 119 to mid 120. Here *Britannia* is perhaps less proud than weary, with her head propped on her right hand – or it may be, as some think, that she is merely pulling up the hood of her cloak (the *birrus Britannicus*). To me this image seems a reflection not of a defeat but rather of a hard-fought and successful campaign early in the reign (perhaps the reason for Hadrian's subsequent visit and the decision to build the Wall).

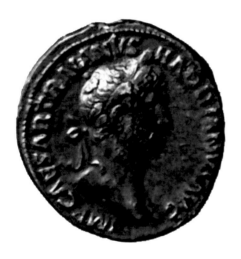

The Hadrian Stone

Jane Gibson

In the '80s and '90s I was a northerner living in London. For my final two years in the capital I was having a recurring dream about walls – drystone rather than Roman, but perhaps the foundations were being laid. I heeded the runes and moved to north Northumberland – Falstone near Kielder.

The locals called it the Roman Wall and I was intrigued. A London friend had given me an antiquarian book as a leaving gift, *The Romance of Northumberland* by A.G. Bradley. Written in 1908, in the chapter called the Roman Wall he refers to the 'controversy…that has made breaches in families and alienated from one another ancient friends'. The controversy was, of course, who built the Wall. 'Two great men, Hadrian and Severus, with nearly a century between them, as mute but rival claimants'.

Fast forward and I am in the Great North Museum, with Bill Griffiths, Head of Programmes and Collections at Tyne & Wear Archives & Museums. He is showing members of the Partnership Board that I chair round the Hadrian's Wall Gallery. We spend time at the compelling reconstruction model which is regularly updated. Everyone lingers by their favourite part of the Wall and we exchange stories and recollections. Then to the Hadrian Stone, the inscription from Milecastle 38. Proof not only of the Hadrian connection but also the role of the Roman army in its construction.

I returned to A.G. Bradley. He tells me that Severus was the acknowledged builder by antiquaries but that Mr. Hodgson, a historian, published his Hadrian theory in 1840 and Dr. Bruce and Mr. John Clayton agreed, so the Wall, our Wall, was no longer the Picts' or Roman Wall. Except maybe to my neighbours in the Debatable Lands.

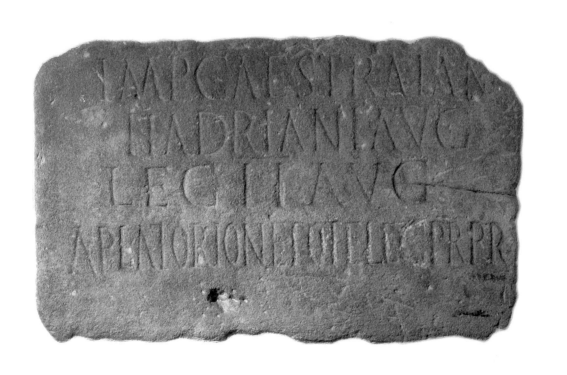

IMP CAES TRAIAN
HADRIANI AVG
LEG II AVG
A PLNTORION[.]ELT LEG PR PR

The Ilam Pan

Elsa Price

Unlike many of my colleagues, I do not have the pleasure of working physically along the Wall, or the opportunity to view it over my working days. What I do have though is the honour of working with the material culture from the Wall. I have found that it is within the museum's collections that we can begin to animate this stone structure with the objects lost, discarded and left behind from the people who have lived and worked along it over hundreds of years.

Tullie House is home to collections from the western side of Hadrian's Wall including sites from Carlisle, Bewcastle and Birdoswald. The wealth of material is both outstanding and overwhelming in its volume and quality. However, in being tasked to think about a favourite or iconic object from the Wall, it could be no other than the Ilam Pan.

As its name might suggest the Ilam Pan, wasn't found along the Wall but in Staffordshire, hence its other name, the Staffordshire Moorlands Pan. What links it to Hadrian's Wall is the inscription along its top edge which names four forts along the Wall: MAIS (Bowness-on-Solway), COGGABATA (Drumburgh), VXELODVNVM (Stanwix), and CAMMOGLANNA (Castlesteads). This is the first thing that I love about the pan because this led to a joint acquisition allowing it to be shared across the country.

Its link to the western side of the Wall gave Tullie House a claim, whilst the findspot in Staffordshire naturally interested the Potteries Museum in Stoke-on-Trent and its international significance prompted the British Museum to take notice. The pan is now rotated across these three museums as joint custodians and, to me, that crystallises the national feeling that many of us hold about the Wall – it has universal appeal and evokes a sense of shared ownership.

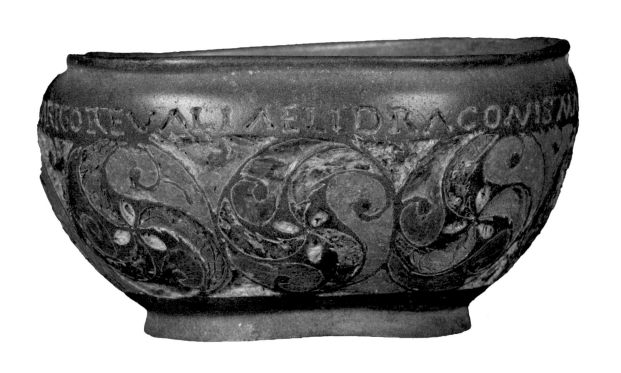

Hadrian's Wall
from East to West

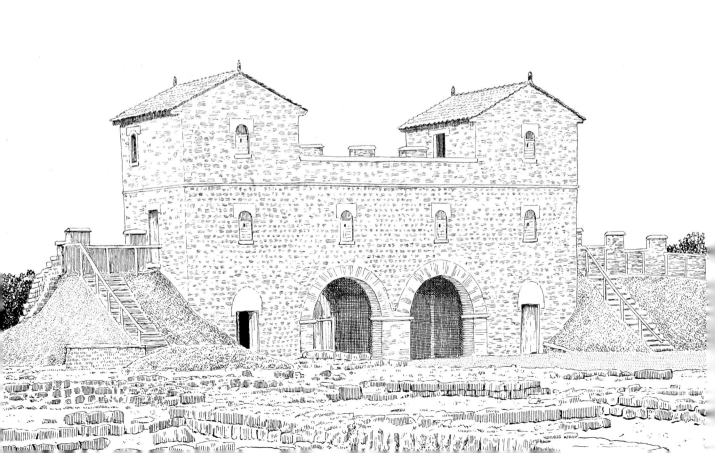

South Shields Roman Fort (*Arbeia*)

John Scott

The Roman fort at South Shields is the eastern end of the World Heritage Site. Even though it is not on the Wall it is most assuredly part of the Wall, not least via its role as a supply base from the 3rd century onwards.

Originally a standard fort, it was enlarged to become a supply base for the campaigns of the African Emperor Septimius Severus into Scotland. Long term excavations have told us much about its plan – and the magnificent reconstructions give a much needed sense of scale to the remains on the site, not to mention a sense of life in the fort. It also serves to demonstrate the multicultural nature of the Roman frontier with magnificent tombstones recording the presence of a Syrian and a North African Moor, while its final garrison is believed to have been a specialist unit of bargemen from the river Tigris, modern day Iraq.

Its majestic setting at the mouth of the Tyne really does emphasise the sense of edge of Empire to me, and serves as a reminder that the World Heritage Site survives and thrives in urban areas too!

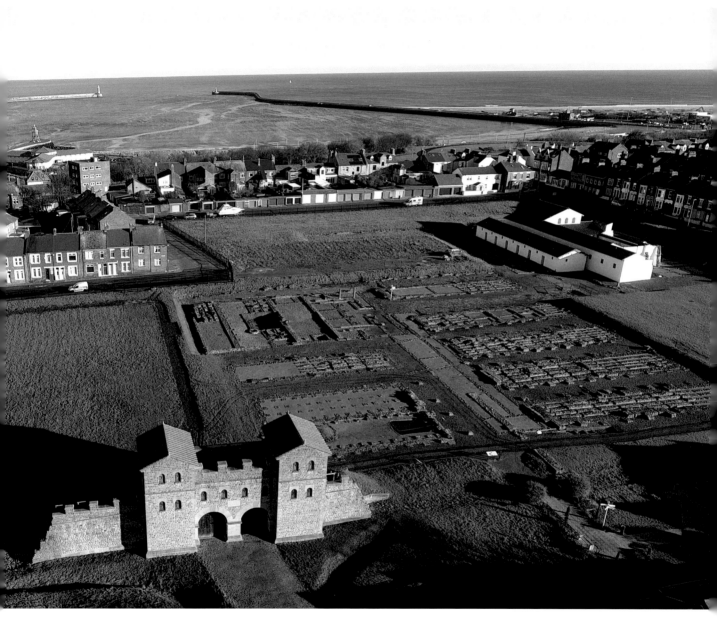

Touching the Void: The Northern Guard Chamber of the West Gateway at South Shields Roman Fort

Roger Miket

It is school holiday, summer 1966. I have just read Christiane Desroches-Noblecourt's Tutankhamen and discovered I want to be an archaeologist. My friend Richard's parents are in the South Shields Archaeological & Historical Society and tell me I can go with him on the dig at the Roman fort in the centre of our town. I am 16, and very excited.

The man in charge of the dig looks like Einstein. After giving me a trowel and showing me how to use it, I am put in a hole which, I am told is 'over the north guard chamber of the west gate'. The chequerboard of deep holes makes it difficult to see exactly what shape this 'gateway' is, but I have my instructions and so start scraping the ground – carefully (I was good at doing what I was told in those days).

To my surprise - for I thought it might take as long an hour before I found anything *really* important - a large circle appeared in one corner of this 'guard chamber'. Even my untutored eye could make out the large broken edge of an unbelievably massive pot, its outline emerging with some rapidity under increasingly enthusiastic trowelling. Einstein appeared and instructed me to empty the soil from within. As I did so another, smaller, flagon-shaped pot emerged (though not quite as complete as Christiane's fine colour photo of King Tut's canopic jars). This was great fun, but a shame about the big hole in its bottom.

Mr Gillam (aka 'Einstein') reappeared and told me I had found the bottom of a large Spanish wine amphora that had been set into the floor by the guard in charge of the gateway. Here he would wait (and wait), and upon having finally drunk its contents he would use it as a urinal – hence the hole in the base.

I was delighted and went home for tea well pleased. Indeed, looking back, I see that this particular discovery set its stamp on my next 60 years in archaeology.

[P.S. Sadly, in 1981 someone had the foolish idea of putting up another building over the site (the Vandal!) and from 1988 my favourite spot was lost from view]

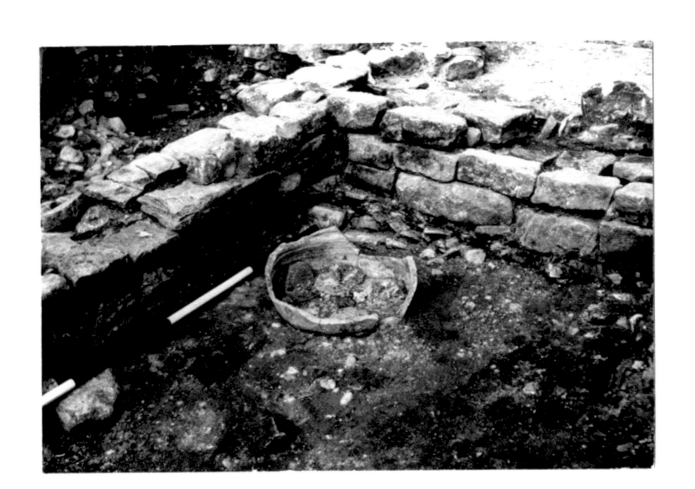

Wallsend/Segedunum

Paul Kitching

It was Thucydides who observed that if all that were left of Athens were the ruined foundations of its great buildings, posterity would assume its power to be double than was actually the case. Viewing the eastern terminus of Hadrian's Wall today, at *Segedunum*, it is easy to understand his point. After nearly two millennia, the ruined foundations still compel us to engage with questions about the power and impact of Rome.

The museum's 35-metre-high viewing platform offers the modern visitor a fantastic birds-eye view of the fort and its surroundings - a vantage point, however, certainly unavailable to the Romans themselves. The influence of differing perspectives could not be clearer; modern research can shed increasing light on the lives of those in the past but cannot assume they saw the world as we do.

The archaeology at *Segedunum* is displayed alongside meticulously researched modern reconstructions; nevertheless, the juxtaposition between what remains and what is conjectured is an example of how interpretation must always fall short of conviction and, as Thucydides cautioned, carry with it the danger of inferring what wasn't there.

From the south-east corner of the fort the Wall reaches down towards the Tyne, a reminder that this was not simply a land barrier but a maritime gateway to the frontier zone, closely connected with the rest of the Roman world. Here, too, is another reminder: a modern memorial to the 'Builders of the Wall', whose names we know from centurial stones they left behind. Thucydides contrasted Athens with Sparta - a city whose lack of great buildings risked it being underestimated by future generations. Likewise, remembering those from the frontier zone whose names have not been preserved in its ruins is a perennial challenge lest history be written, if not by the winners, then solely by the builders.

The Fallen Wall at Wallsend

Alex Croom

I really like this stretch, just 100 m away from Wallsend fort, as it vividly shows that the Wall had a history of alteration and change, and rather than being this solid, unchanging feature in the landscape it could be remarkably fragile. On the left-hand side, coming in from the north, can be seen a shallow dip filled with some leaves which marks the location of a small stream that was taken through the Wall in a small culvert. The stream caused no end of trouble, and this section of Wall was undermined by water weakening the underlying clay on numerous occasions, no doubt sometimes after storms, relentless rain, and flooding.

To the south, on the right, can be seen the tumble of stone blocks that were left where they fell after this part of the Wall gave way; ironically these large stones had been used to patch up an earlier collapse. On the left-hand side of the Wall there is a curved section of facing stones, where the courses have gracefully slid over each other when the wall slumped to the south as it fell. And then finally, in the background, there is a patch of light-coloured modern pebbles marking the position of a medieval road that was cut through the ruins of the Wall at a time when no-one had any concerns at all for it other than as a useful source of stone.

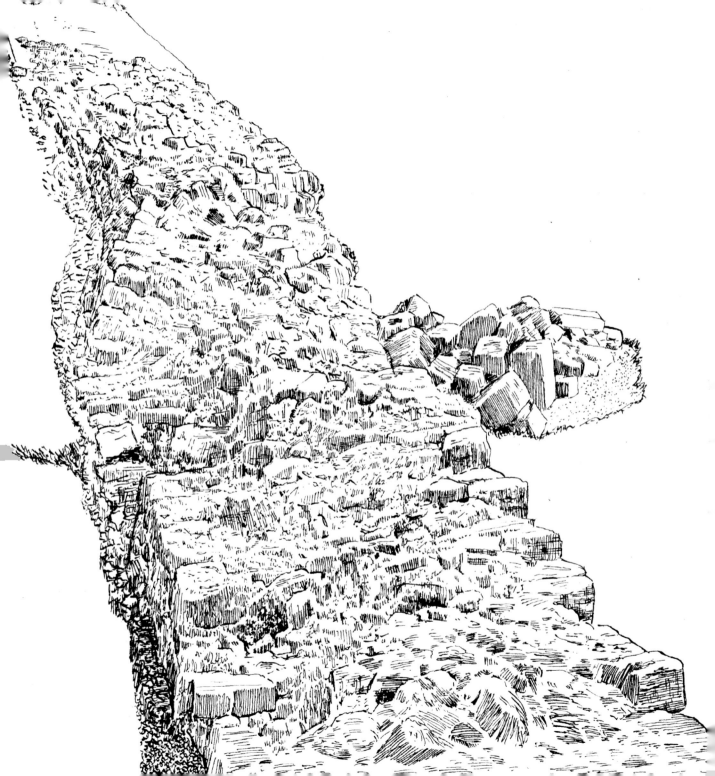

Hadrian in Suburbia

Sue Ward

My favourite section of Hadrian's Wall is at Denton Burn, in the western suburbs of Newcastle, just before the junction where the A1 crosses the West Road (the A69). It includes Denton Hall Turret (7b) but even with this it is no more than a scrap and is severely robbed out. I love it for its survival against all the odds. It lies only yards from the very busy West Road, with a road cutting and huge roundabout straight ahead. Up until the 1980s it would have been part of a much longer stretch, running through to the similar scrap on the other side of the roundabout, but over a hundred yards of Wall, and a substantial chunk of Vallum, have been sacrificed to the motor car. The Western Bypass scheme was first devised in the 1930s, apparently with the acquiescence of leading archaeologist Sir Ian Richmond, who took the view that nothing new remained to be discovered about the Wall. A wide corridor was safeguarded against the post-war housing developments transforming the area, and by the time the road plan came to fruition in the 1980s, planners and councillors felt that no other route was practical. The best that could be done was a three-year long excavation before destruction started, with a report finally published in 1996.

The small strip and the turret, sitting on a green bank beside the road, are now well cared-for. They feature in the short film *Gannin' alang the Wall*, made in 2023 about the route of the Wall through Newcastle and to Wallsend. The grass is litter-free, and a wooden bust of Hadrian sits on a fence just beyond the end of the stretch, commissioned by a nearby resident because he thought Hadrian deserved some respect.

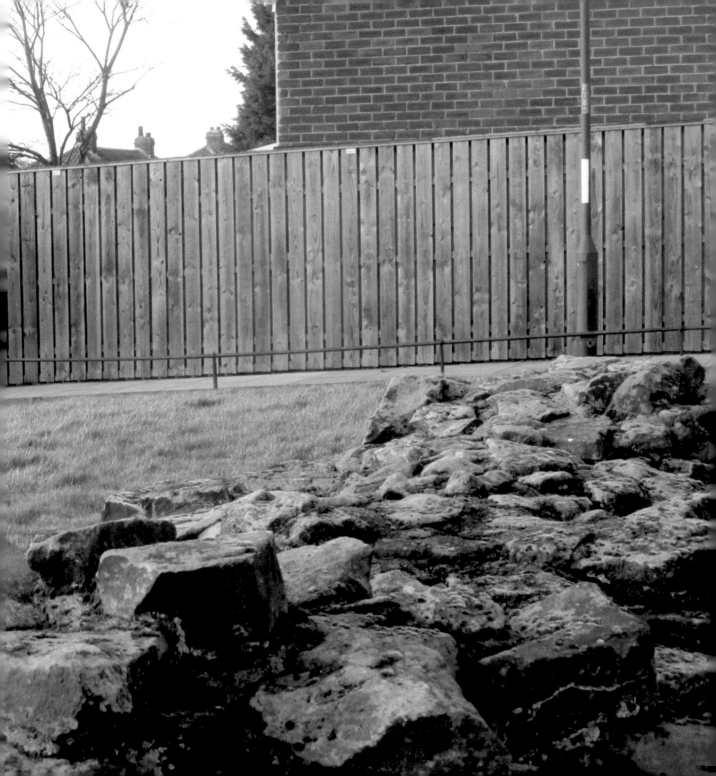

The Vallum at West Denton

Mike Collins

One of the privileges of working on the Wall is the chance to see so much not on the traditional Hadrian's Wall tourism trail. The last 20 years have seen great strides to open up more of the Wall landscape, particularly through the National Trail. However, there are still parts of the Wall, particularly on the west coast and on Tyneside, which remain unexplored and comparatively unknown to the outside world.

I also love that in these areas the Roman remains are valued and used by their local communities in ways that they define and mean most to them. The Vallum at Denton, in the west end of Newcastle, in this photo is a great example of this. I've been here many times, and it clearly is a cherished space for its local community – the remains of the Roman defences are appreciated, but also used for football matches and even polling booths.

Whilst I love the wild central sector, and will never tire of Vindolanda and Housesteads, it is the overlooked parts of the Wall which I cherish, and which still represent an untapped resource to deliver more economic, educational and social benefit to the benefit of us all.

The Roman Bridge at Chesters

Bill Griffiths

The surviving remains of the bridge crossing the River North Tyne just to the east of the fort at Chesters are an oft missed part of the Wall. Yet they are also the clearest evidence in its whole line for the engineering skill of the Roman army, and for changes to the barrier through time. Under Hadrian a footbridge was constructed, but it was upgraded to a road bridge later on. Visitors can still see one of the small piers of the original footbridge embedded within the east abutment of the later road bridge.

The river has shifted slightly westwards since the Roman period, leaving the east abutment high and dry(ish). The west abutment and piers of the later road bridge can still be seen in the river in favourable conditions. Dovetail clamps and other features designed to hold the massive masonry blocks together are still visible today, and bear testimony to the enduring skill of the Roman engineer, not always visible in the rest of the Wall.

I have fond memories of surveying the remains of the bridge in the river – wetsuit clad and using a bucket with a clear perspex base to enable me to see the stones under the surface more clearly.

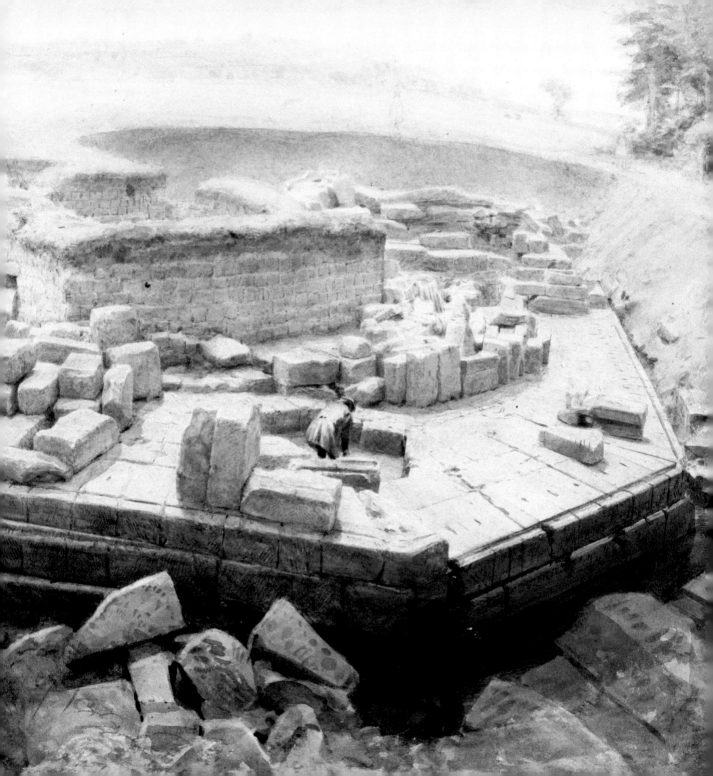

Stepping into the Past – A Threshold at Chesters

Christof Flügel and Jürgen Obmann

The extraordinary and substantial preservation of Roman stone architecture on Hadrian's Wall is stunning, especially for archaeologists from the continent. And rarely has any other fort on the Wall produced so many well-preserved door sills as at Chesters (*Cilurnum*). The worn step into a sequence of rooms in the so called commanding officer's baths shows heavy use in antiquity. Still preserved and visible are the pivot holes which prove the existence of door leaves on both sides. All these details are seldom found elsewhere on the frontiers of the Roman Empire and make Roman stone architecture on Hadrian's Wall an important source for reconstructions.

The accuracy of the recesses for the monolithic door soffits testify to Rome's solid and prolonged imperial claim: we built to last, even in a small military bathhouse. But apart from architectural and archaeological details, this entrance predominantly tells the story of numerous tired and chilled-through soldiers seeking warmth and relaxation after a long day securing the northern edge of Empire.

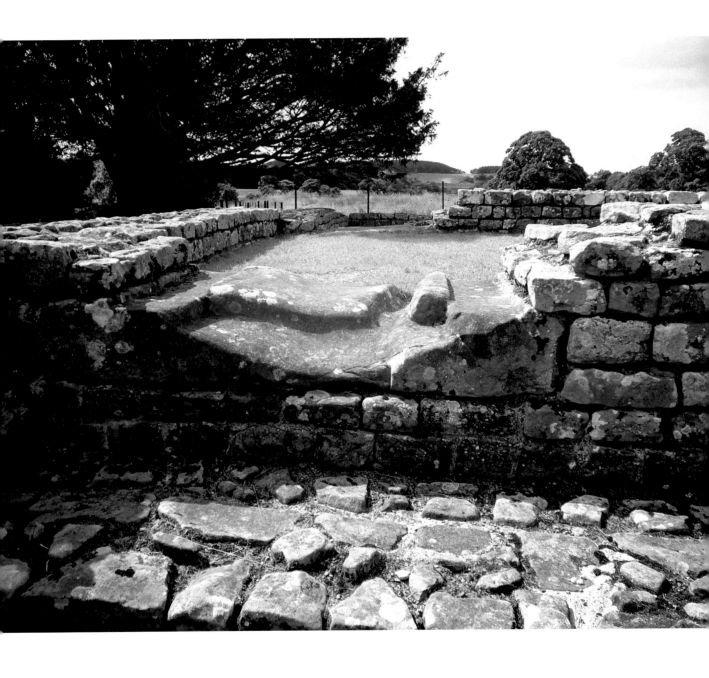

Turret 29a (Blackcarts)

Tom Hazenberg

From Chesters (*Cilurnum*), it is half an hour's walk along Military Road (B6318) through Walwick - with an exciting passage through a meadow of young bulls - before reaching Black Carts. A green field with a tree here and there offers a wonderful stretch of several hundred metres of ditch and Wall. A true reward so early on the sixth day of my Hadrian's Wall Walk in 2017. In the middle of the Wall, the ruins of a turret can be seen, Turret 29a (Black Carts). The north wall is still standing up to eleven courses. The south wall still shows a threshold with a pivot-hole. This contained the door that guarding soldiers pushed open in search of their resting place inside. On either side of the turrets, wingwalls stand out, testimony to the army command's decision to no longer build a Broad Wall but a Narrow Wall.

During my Hadrian's Wall Walk, I had access to the best guidebook: the *Handbook of the Roman Wall*, both the fourteenth edition from 2006 and the third edition from 1885. The happiest moments were those where the modern situation merged with the image that John Collingwood Bruce himself had captured in his guidebook. Turret 29a formed one such highlight. For a moment I could imagine myself following in Bruce's footsteps overlooking the turret excavated a few years before. Still unaware of the fact that Bruce would have been better off using a different woodcut for his handbook, as sharp followers of his work would discover almost 140 years later. It doesn't detract from the pleasure that a hike along Hadrian's Wall has to offer by constantly painting a picture of life along northern borders of the Roman Empire. As researchers have been doing for several centuries.

a piece of the Wall, frequently covered with honeysuckle and other plants, and presenting four courses of facing-stones in position. The fosse behind it is used as a duck-pond. Beyond this, the foundation of the Wall forms the slightly elevated crown of a path leading through the plantation. The Wall is seen to the north of it.

Emerging from the grounds of Chesters, we are once more upon the turnpike road, and climb the hill which leads to Walwick. The lines of the Vallum are seen in the field on

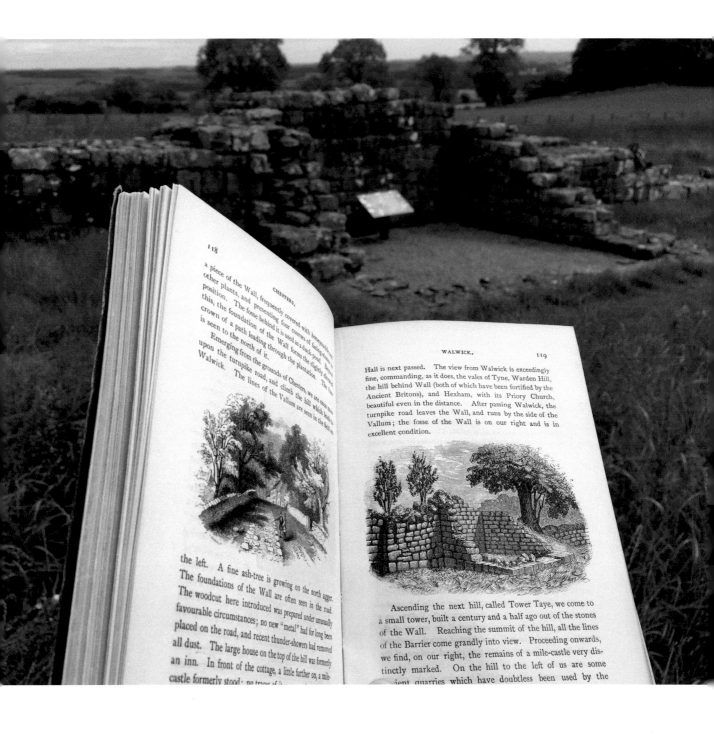

the left. A fine ash-tree is growing on the north agger. The foundations of the Wall are often seen in the road. The woodcut here introduced was prepared under unusually favourable circumstances; no new "metal" had for long been placed on the road, and recent thunder-showers had removed all dust. The large house on the top of the hill was formerly an inn. In front of the cottage, a little further on, a mile-castle formerly stood; no traces of it

Hall is next passed. The view from Walwick is exceedingly fine, commanding, as it does, the vales of Tyne, Warden Hill, the hill behind Wall (both of which have been fortified by the Ancient Britons), and Hexham, with its Priory Church, beautiful even in the distance. After passing Walwick, the turnpike road leaves the Wall, and runs by the side of the Vallum; the fosse of the Wall is on our right and is in excellent condition.

Ascending the next hill, called Tower Taye, we come to a small tower, built a century and a half ago out of the stones of the Wall. Reaching the summit of the hill, all the lines of the Barrier come grandly into view. Proceeding onwards, we find, on our right, the remains of a mile-castle very distinctly marked. On the hill to the left of us are some ancient quarries which have doubtless been used by the

Limestone Corner

Al McCluskey

'Sweat saves blood!' It's an old military dictum, but few who have constructed military fieldworks by hand will forget the experience. Hands rubbed raw; eyes stinging with sweat; limbs aching with fatigue; and an oppressive need to dig deeper against an unforgiving clock that marks the anticipated enemy attack. 'Sweat saves blood!'

As a former soldier, it is for this reason that I find Limestone Corner such an evocative place. The location doesn't have the cachet of the other sites or vistas along the Wall, and until the establishment of the Hadrian's Wall Path it drew few visitors. But if you've dug trenches through the solid chalk of Salisbury Plain, or the baked clay of Breckland, or the sands of the Senneheide, then you gaze into the ditch at Limestone Corner with a sense of awe. To cut through the hard quartz dolerite bedrock and remove blocks weighing tons with only iron, wooden and rope tools to help is breathtaking.

If you want to get close to the experience of a Roman soldier, there is no better place. Look north. Sense the enemy threat. And remember; 'Sweat saves blood!'

Busy Gap

Jim Crow

It is well known that in 1599 William Camden took the 'low road' past Housesteads 'for fear of ranke robbers thereabouts'. But at the time the place that mattered was not the fort and settlement but a quiet cleft in the Whinsill crags east of Housesteads where a field gate opens north out into the loughs, flows and waste, now the Wark Forest. Tracks lead on towards a farm called East Hotbank where Tommy Carr the last tenant farmer at Housesteads was born and walked to school at Sewingshields crossroads. The Ordnance Survey mark the gate as the King's Wicket but generations of Wall-scholars know the place as Busy Gap. It is among the oldest known place names in the central sector first attested in the 1530s from a letter to Henry VIII's keeper of Tynedale, Sir Reginald Carnaby, reporting how 'came Liddisdale men the barony of Langley (Haydon Bridge) to the number of six score and laide them at the Buise Yappe'. Among the freemen of Newcastle 'Bussey-gap rogue' continued as a term of invective into the following century. But what was Busy about this empty place? Today we see a V-shaped earthwork set north and later than the Wall about a hectare in area. An air photograph shows traces of cord-rigg below the earthwork but most likely the enclosure was a corral for stock mustered for summer grazing. As such times stockmen and rievers gathered, outsiders all and from where drove roads linked north to south.

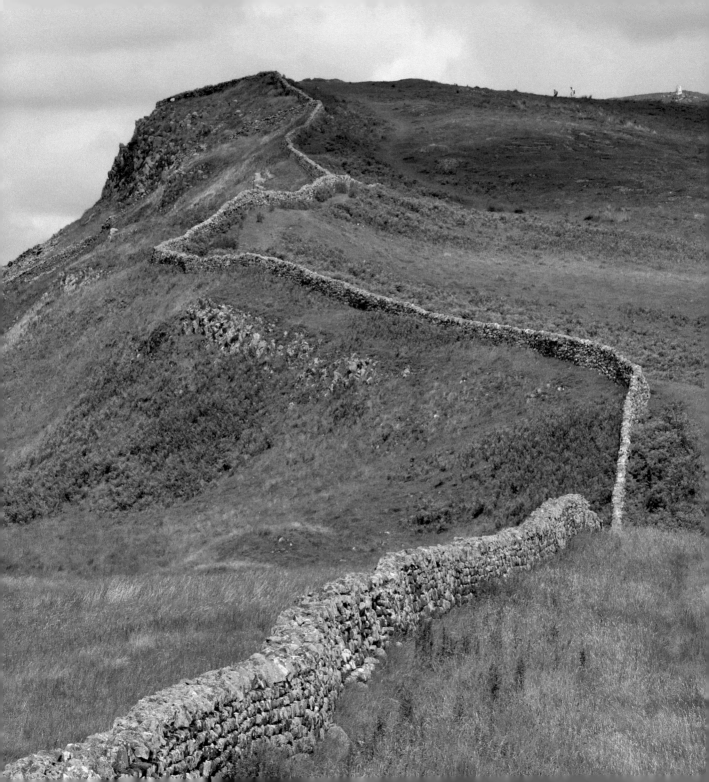

Knag Burn from Housesteads

Eleri Cousins

I was sixteen when I first came to the Wall. My parents, desperate to dissuade me from pursuing archaeology as a career, sent me to confront the reality of mud and hard labour at the only Roman excavation they could find (at least, via the internet from Los Angeles) that took teenagers. This happened to be Vindolanda, however, an unfortunate choice if you want to convince someone that excavation is monotonous. My doom was set – I would be not only a Roman archaeologist, but an archaeologist of Roman Britain. (So much for Mediterranean holidays.)

A few years later I was back, researching my undergraduate thesis on religion at Vindolanda and Housesteads. My abiding memories of that summer are the weekend days I spent walking as far as I could on the National Trail, the Wall swooping along besides me through the gloriously expansive Northumberland landscape. This view from Housesteads down to the Knag Burn captures the essence of those days for me: the Wall, the woodlands, the grand diagonal line from the top of Sewingshields Crags in the far distance – and yes, the sheep. And a remembrance of the beginning of deepening knowledge: of learning that sculptures of mother-goddesses were found by the burn, of wondering how the people of this place wove the divine into the fabric of their lives. That magic, so peculiar to archaeology, of knowing your subject with your whole body as well as with your mind.

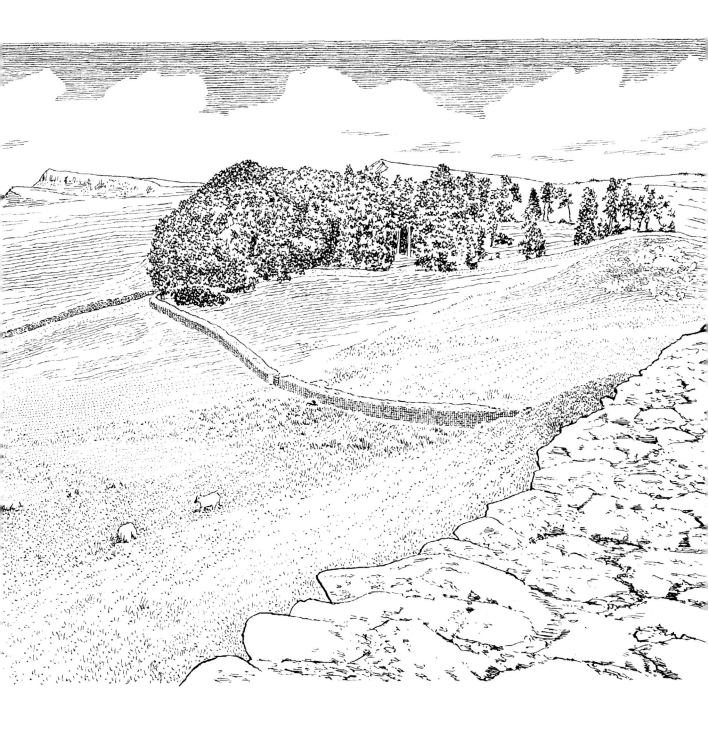

Housesteads Fort

Nick Hodgson

The Roman sculptures and inscriptions littering the ground that so astonished 18th- and 19th-century visitors to Housesteads have long since been removed to museums, but the grey and lonely ruins cannot fail to take the breath away. My first dig: here as a teenager I first put trowel to earth and so started on what became life's course. Against an unchanging backdrop our predecessors feel close: it was here that the scientific study of Roman forts began, when in the 1830s, rather than just hoping to dig up antiquities, Anthony Hedley and John Hodgson set out to find out about 'the stationary economy of the Romans' – what life was really like in these places. It was also the first fort in the Roman world to produce anything like a complete plan (from digging in 1898), which was the standard one to appear in books until the stratigraphic excavations of the later-20th century taught us much more. But it is really all about the setting. Looking out to the north, over a vast waste where 'a proud stupendous solitude frowns o'er the heath', the visitor is forced to ask: why did the Romans choose such a remote place to build on a giant scale, and work, and worship their gods? And why did it all come to be abandoned, how did a place once so busy become such a desolation? It is always worth coming back to experience the sensation of curiosity triggered by 'august remains of Roman grandeur' in an unpeopled landscape. This is what made me want to become an archaeologist.

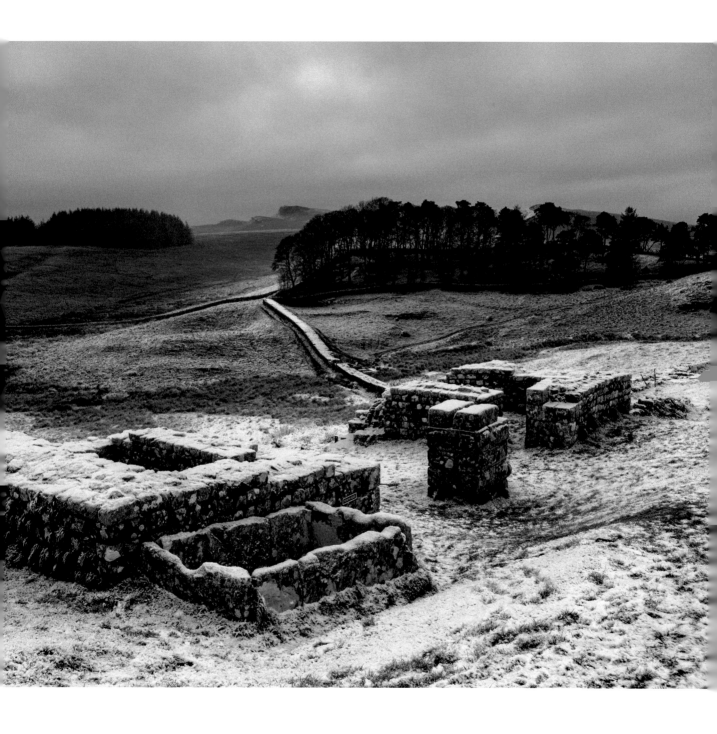

Milecastle 37 (Housesteads)

Erik Graafstal

Our search for a new Wall icon must include milecastle 37. Sitting a mere 400 m west of Housesteads Roman fort it is probably the most visited installation of its kind. It is certainly one of the more 'readable' examples for a lay person, its remains including a well-defined barrack block and, above all, the highest surviving arch of Hadrian's Wall. Encased by walls rising up to 2.2 m, the north gate gazes wide into the 'barbarian' foreland, poised above a steep precipice of the Whin Sill escarpment. Excavations were carried out in 1853, 1907, 1933 and 1988, providing a relatively rich information base. This includes a dedicatory inscription by *Legio II Augusta* dated to the governorship of Platorius Nepos (122–c.126). Structural details like the tapering width of the north wall make 'MC 37' a key element in the early development of Hadrian's Wall. Particularly well-researched is the iconic north gate which was drastically narrowed at some stage. We even have two altars, inscribed to Jupiter and Cocidius, illustrating life at this outpost. Yet, for all this wealth of detail, milecastle 37, like all the others, remains 'one of the great mysteries of the Wall', to quote Brian Dobson. Could civilians use (or bribe themselves through) these frontier passages? Why were fortified gates provided at every mile – even where a precipice seems to deny passage? Why were many gates narrowed? How many men operated these double-gated installations? Did they form a functional unit with the two adjacent turrets? For how long were crews outposted to such installations – do the altars show them taking root over time? As we gaze out of milecastle 37, our view framed by its mighty north gate, we realise how much there still is to discover about Hadrian's Wall, one of the iconic monuments of the Roman Empire.

Milecastle 40 (Winshields)

Peter Savin

The question of what makes milecastle 40 so special for me isn't hard to answer. As a resident of the Lake District, I'm drawn to high tops – and Winshield, at 345m (the highest point of Hadrian's Wall), fits the bill perfectly. The views to the south and east of the grassy ruin of the milecastle are sublime, with Crag Lough sitting below the lofty Whin Sill cliffs which rise to meet the Roman Wall so carefully placed along its edge. A May evening is my favourite time to be there – warm, with the haunting sound of curlews on the wing. The north ditch, usually flattened in the daylight, deepens with the raking light of the setting sun, and its abrupt end connects the modern viewer with thoughts of the Roman engineers who long ago realised the futility of building a ditch under the Winshield cliffs. To the south-east, the long summit top of Barcombe Hill can be spied – and below it and out of sight, lies Vindolanda which seized my imagination over a decade ago and still draws me back. From here, sunsets from the north-west flood the frontier with golden light before turning it a deep, dramatic red.

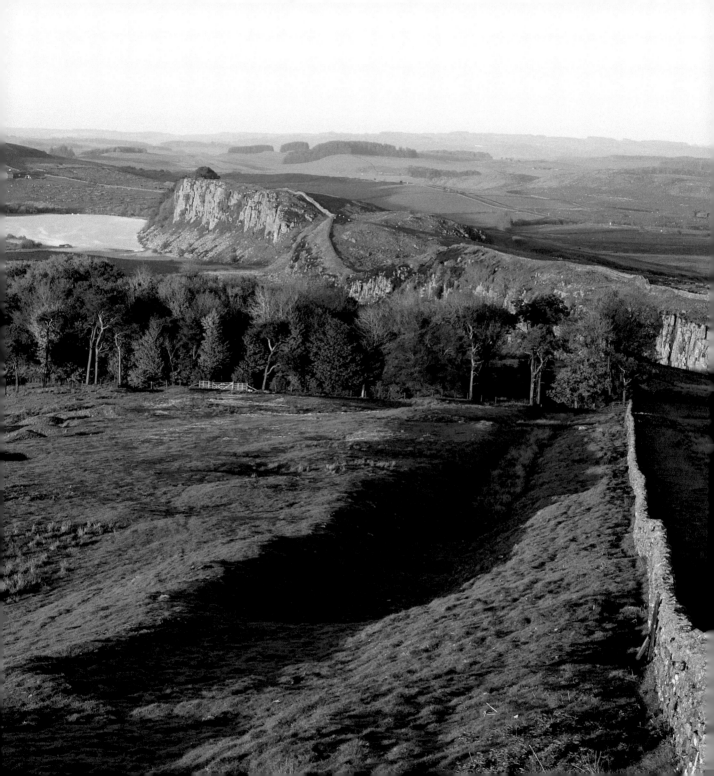

Winshields

James Silvester

The imposing sight of Housesteads during a visit in 2019 was my first experience of the majesty and importance of Hadrian's Wall. With only a beginner's knowledge to fully appreciate the complexity of its history, I was left with a new curiosity and awe which led me to undertake a trip along the entire length of the trail, east to west, from Wallsend to Bowness-on-Solway. These central views, including Peel Gap and its formerly iconic sycamore, are among the most recognised views in the world, and truly worthy of their UNESCO World Heritage status. Each milecastle and turret has its importance, and many mysteries still remain tantalisingly buried underground. Seeing with a photographic eye, I was often more engaged with the views which put the Wall and its landscape into perspective. The view I have chosen is located between Winshields trig-point and turret 41a (Caw Gap), on the descent from the highest and most central point of the Wall. Those with a more casual interest often rate this segment as one of the most captivating parts of the Trail, and what it may lack in historic interest, it matches in unobstructed views of the landscape and sweeping terrain. It is some comfort to me that even in light of recent tragic events, the majesty and grandeur of these vistas and environments can never be diminished. As they have been for centuries, they will continue to be.

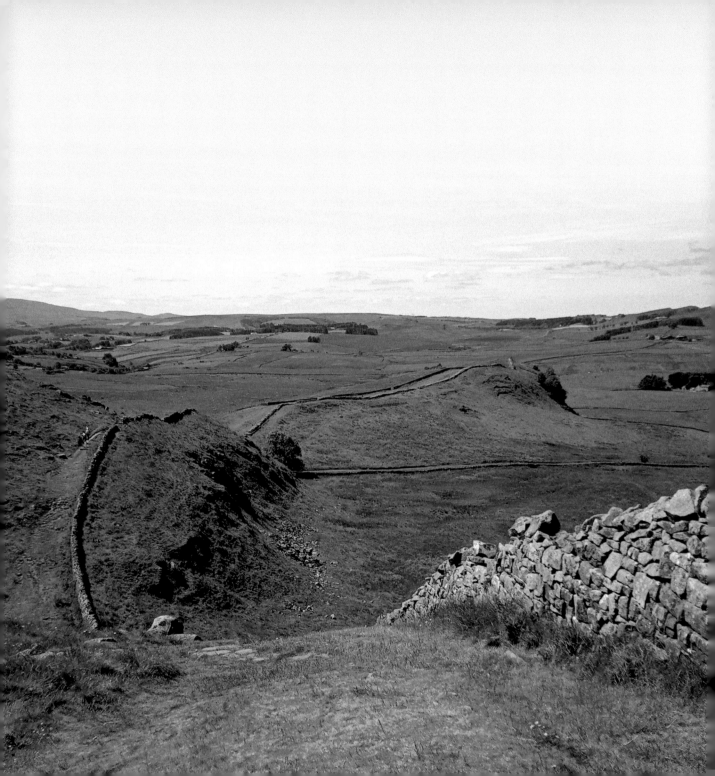

Thorny Doors

Carole Raddato

Hadrian's Wall runs through some of the most beautiful and often dramatic countryside I have ever seen. Its magnificent scenery never ceases to amaze me. Over the years, I have developed a strong emotional attachment to the place, walking small sections of the Wall, most often alone, with my camera in hand. I was fortunate to spend long hours along the Wall in 2022 and 2023 while excavating at Vindolanda and participating in the Hadrian's Wall 1900 Festival. While there are many awe-inspiring sections of Hadrian's Wall to immerse yourself in, including the once-iconic and captivating Sycamore Gap, I often enjoy returning to one particular small stretch of consolidated Wall between Caw Gap and Cawfields at Wall Mile 41: Thorny Doors.

At Thorny Doors, Hadrian's Wall beautifully drops and snakes its way into a small gap. The Wall here stands an impressive 10ft (3.05m) high, although it is pierced by a modern hand gate. There is a flight of stone steps along the footpath where I like to sit for a long moment, reflecting on my Following Hadrian project or simply enjoying the elements. From this spot, a fine section of the Vallum, which runs in a straight line parallel to Hadrian's Wall on the south side, can be seen stretching away to the east. I also enjoy sitting and reflecting from the top of the steps east of Cawfields Quarry to admire the views of milecastle 42, located on a steep slope in a wonderfully scenic spot with clear views across the Wark Forest on the horizon. It is one of the most photogenic views along the Wall. I always look forward to returning to these unique places to marvel once again at the wonders of Hadrian's Wall.

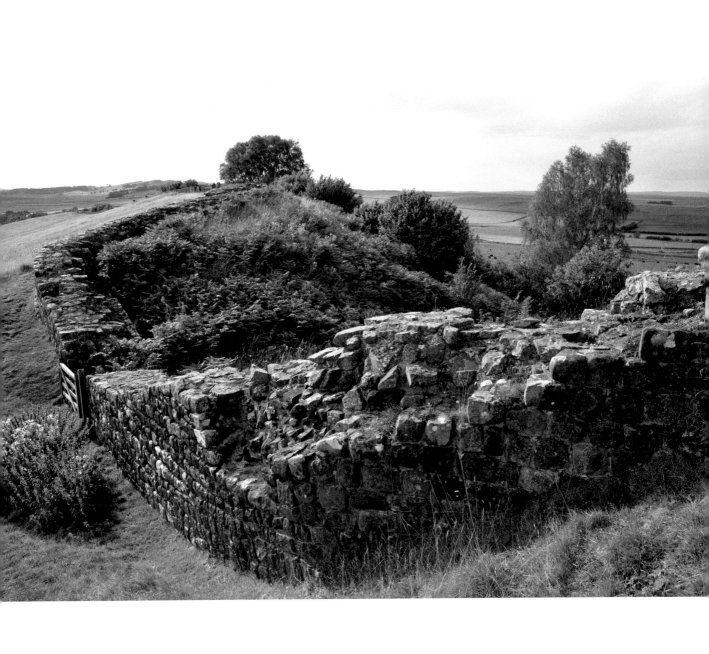

Great Chesters Viewed across Haltwhistle Burn from the Milecastle Inn

Amy Baker

Sitting at a table outside the Milecastle Inn, the eye is drawn to milecastle 42, stamped at a comical angle on the green-brown landscape, and the Wall beside it rising steeply to the sudden void of the 20th century quarry. However, the landscape to the west is, somehow, even more dramatic – best viewed as the setting sun dips low over the distant 'nicks' and leaves the fields in a hazy half-light. In the foreground, cattle ebb and flow across the earthworks of Haltwhistle Burn fort, excavated in 1908, and the line of the Stanegate road. The platform of Great Chesters, *Aesica*, is visible beyond at a squint; excavations here in the 1890s by Gibson and the Society of Antiquaries of Newcastle upon Tyne found remarkably well-preserved walls and gateway to the west, with multiple phases of stonework. Gibson imagined *Aesica* experiencing the 'rude test of Barbarian assault', but nothing disturbs the landscape today except occasional traffic roaring along the Military Road.

The view is best appreciated with a pint of Prince Bishop after returning from a hike east to Housesteads, or west to Walltown, which affords a weary camaraderie with walkers coming from Cawfields to drop into Haltwhistle, glancing hopefully at the bus timetable as they pass. There are many archaeological riches in this view – two forts, two roads, the Wall, several camps, a milecastle, the Vallum – and it offers a sweeping appreciation of the impact the Roman army would have had on this now sleepy landscape.

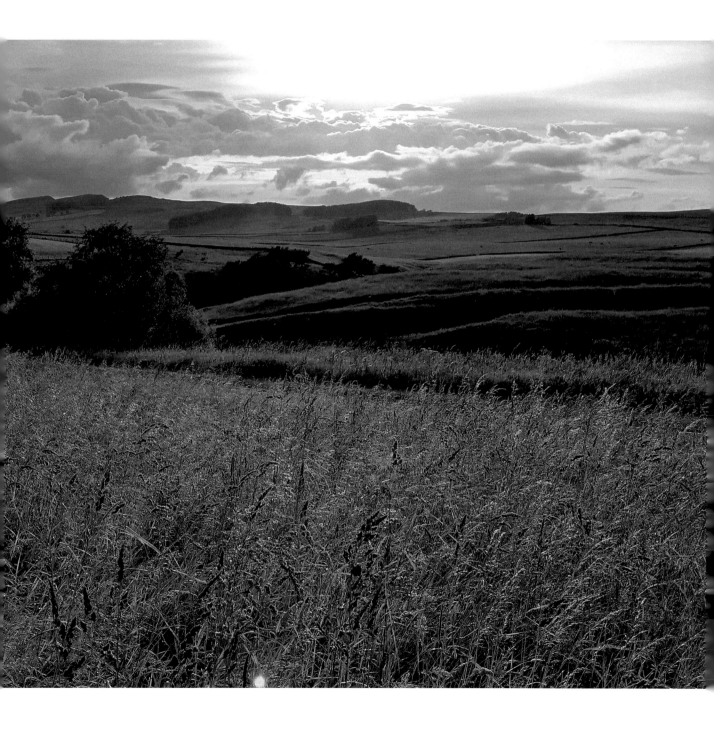

Mucklebank Turret

Elizabeth M. Greene

Look carefully or you just might miss it. If you're walking west to east, my preferred direction, you've passed milecastle 45 and you have your head down, breathing hard from climbing the steep crag. Well done for choosing the high road and continuing the ascent, even when an alternative path presented itself just a minute ago. The accomplishment of the day is starting to set in. You're half-way up this climb and you can see the peak of this particular crag just a few more stepping stones further… but stop, look around, off to your left is Mucklebank turret (44b), one of my favourite spots on the Wall. Its prominent and standing tall, yet still easily missed, perhaps for its quiet countenance as it stands sentinel over this dramatic ninety-degree turn of the Wall. Mucklebank is a small turret, nestled exactly where it needs to be. From experience I can confirm about ten archaeology undergraduates fit inside while you get a fabulous group photo from the rubble pile above. It's a fantastic spot to bring students - its door looks like a door, its walls stand tall, and its purpose is clear. Mucklebank is an iconic spot on the Wall, tucked away quietly, waiting for visitors.

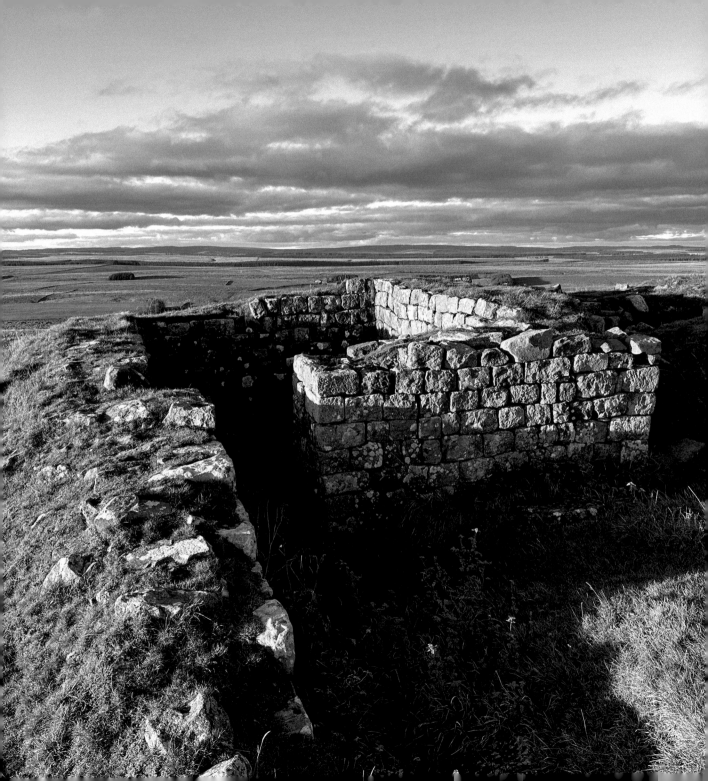

Walltown Crags

Matthew Symonds

Quarrying scars run deep at Walltown, robbing it of a rugged grandeur that once outshone the crags farther east. Even so, Walltown still holds the upper hand when it comes to another quality: tranquillity. An army of hikers may have replaced the Roman military along much of the crags, but it is still possible to find serenity at Walltown. This seems apt, as peace lingered here for longer in the Roman period, too. We know that this frontier segment was among the last to be built. By the time this ground rang with the sounds of building operations in full swing, the soldiers charged with the Herculean task of delivering the Wall had already endured a long and doubtless trying process of trial and error. At Walltown, we can contemplate what they had learned.

One lesson can be gleaned from a tucked-away length of curtain that turns gracefully to glide past a rocky outcrop. It is a small detail, but a telling one. Much of the Wall's modern appeal comes from the drama of Roman ruins crowning stunning scenery, but the effect can be jarring. Often the curtain runs straight for as far as is practically possible along the crags, leaving it ploughing stubbornly across serpentine contours. It is a different story at Walltown. Here, the curtain assumes a longer, more meandering course as it tacks close to the crag edge. Presumably this refinement flowed from a realisation that wringing every last advantage out of the landscape heightened the Wall's effectiveness as a barrier. To the modern eye, this pairing of curtain and crag; ancient and natural is nothing short of sublime. And yet, if the divisive motive to fashion a more potent instrument of division makes this beauty bittersweet, perhaps that is just as Hadrian's Wall should be.

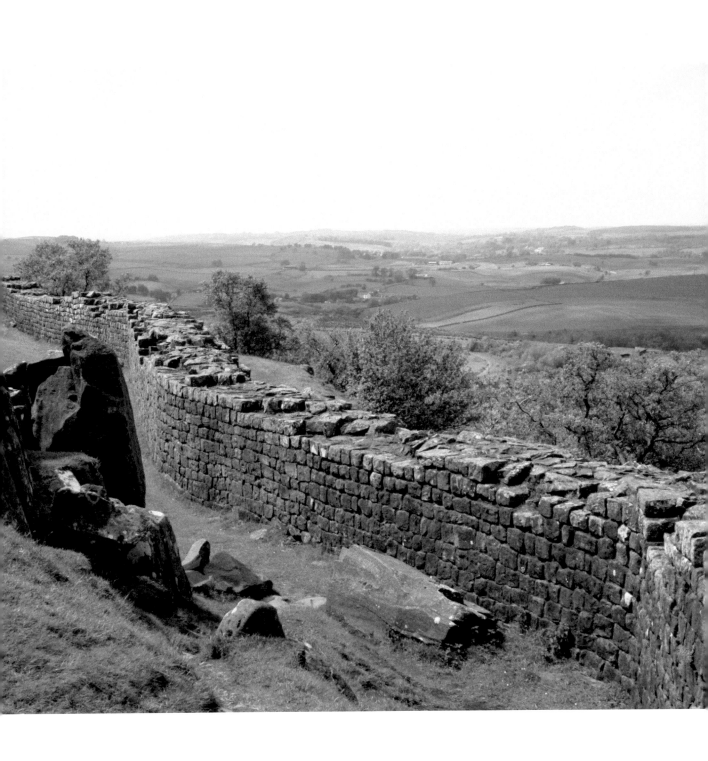

The Ditch at Gilsland

Abigail Cheverst

I fell in love with one field on the Wall pretty much the first time I walked through the gate. The majestic sweep of one of the finest examples of the north ditch I had ever seen, the view from the higher ground, over the river gorge to The Kings Stables / milecastle 48 / Poltross Burn - whatever you choose to call it, it remains one of the best preserved and extensive milecastles on the Wall. It was a few months later by a complete quirk of fate that I discovered the field was for sale! I bought it and have since spent many happy hours in the field. I like to enter the field through the gate that carries the National Trail from the east. The trail turns to the north to go under the railway but you can follow the ditch in a majestic sweep as it heads down toward the river. One wonders why the ditch is so deep and prominent in this area? With your eyes you can follow the line of the Wall along the existing boundary, as a 'lump' in the smaller field approaching the river then, in winter, in a perfect line with the revealed milecastle wing wall. In many ways the disconnect is as strong as the connect. The wide and powerful stone transforms to the gentle grassy mound, the narrowness of the rift that separates them rendering it almost unseen. An unresolved question is how the Wall got over the Poltross Burn. It's a question I'm actively exploring.

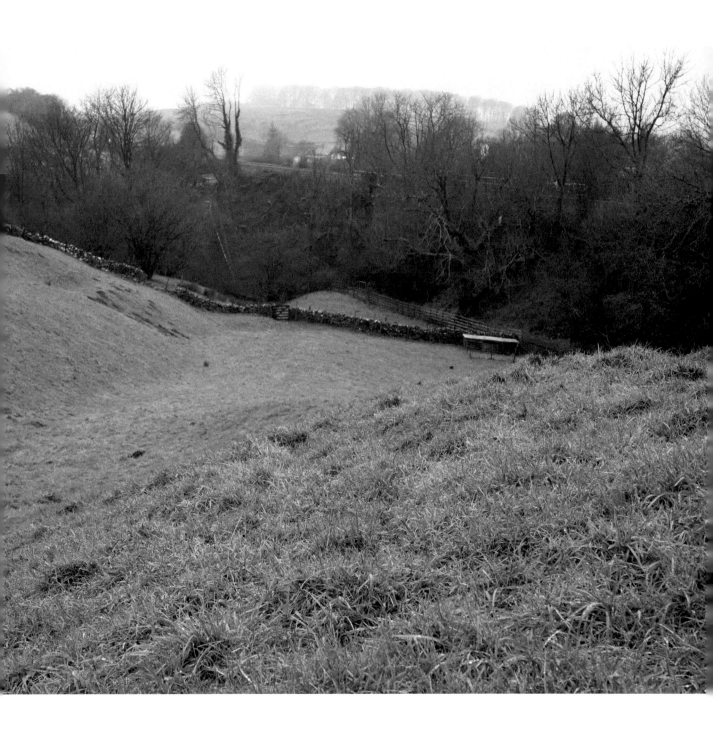

Milecastle 48 (Poltross Burn)

Ivana Protić

During the 2019 Hadrian's Wall Pilgrimage, when I had the honour of being a bursary student enrolled in this event, I had the great opportunity to walk the Wall for the first (but surely not the last) time. Coming from a quite different frontier in my homeland (the Danubian Limes), the Wall, turrets, milecastles and the surrounding green landscapes completely blew me away. Among all these sites, the surviving remains of the Poltross Burn milecastle (or milecastle 48) left a striking impression on me, since, due to its state of preservation, it provided an immersive experience. Being situated to the east of the river Irthing, this milecastle awakens adventure for every visitor with its approach, which involves crossing a footbridge to reach it. Poltross Burn is one of the best preserved and largest milecastles and is an extremely important part of the defence structure. The day I saw the remaining parts of the construction I got the idea of how large and magnificent this construction was. The realization that it could house around 30 soldiers was astonishing, and the historical significance of its use in the late 4th century was particularly impactful for me. It solidified the sense that I was standing beside a testament spanning centuries, showcasing engineering and strategic planning.

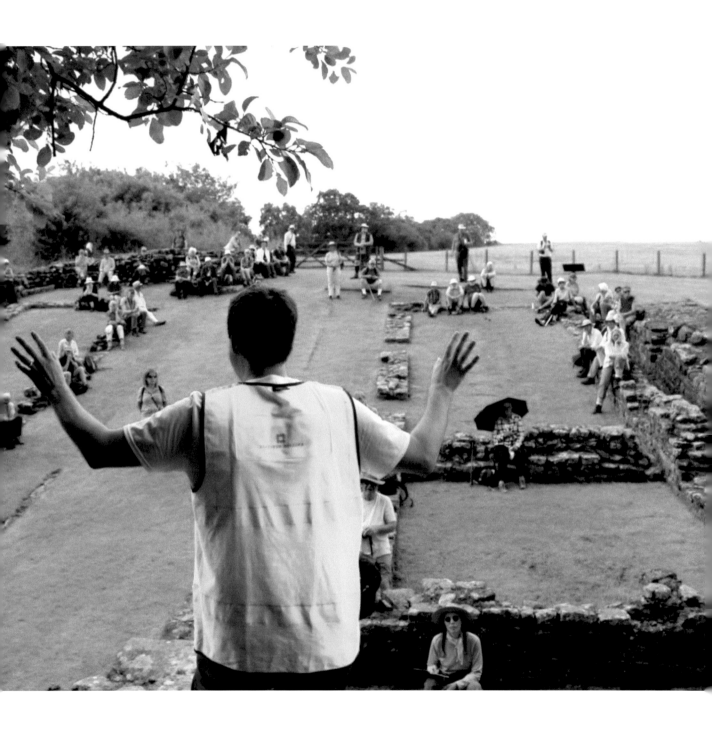

The Irthing Gorge at Birdoswald

Tony Wilmott

The view from the cliff edge south of Birdoswald fort is to me the finest on the whole length of the Wall. The eye is drawn across the river, caught in the slow process of forming an oxbow lake, up to Blackbank Wood and the site of the fort cemetery to the west, and southward to the bulk of Cold Fell, and just visible beyond, the Lakeland Fells. The Pre-Raphaelite 9th Earl of Carlisle, George Howard memorably compared the view to that of the River Scamander from the site of Troy 'if Troy it was'.

I first saw it at the age of 16 on an A-level school trip, then on excursions from Newcastle as an undergraduate, and afterwards guiding groups to the Wall. I would always, and still do, walk backwards to the edge so I can see the surprised expressions on the faces of my group, as they approach the edge before the full vista opens up dramatically before them.

Before the 1980's the way in was through the farmyard, alive with chickens. One asked at the house for permission to visit, paying a small fee. At the time only the fort walls were visible, and the farmer, John Baxter, would always say 'make sure you look at the view'. Since 1987 I have directed fourteen seasons of excavation at Birdoswald, and the working day is not complete without a quiet look at that superb view.

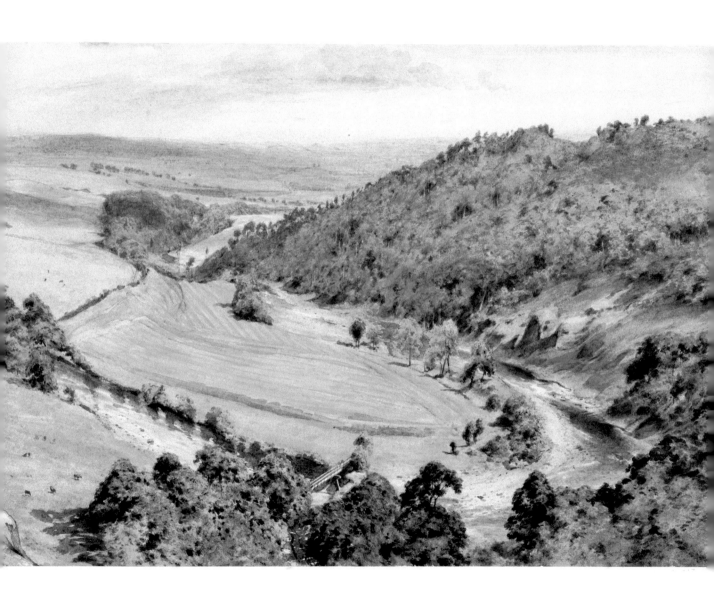

The View West from Birdoswald Fort

Katie Mountain

If you had asked me when I was a child what was my favourite place on Hadrian's Wall, I probably would have said Sycamore Gap, having been there many times with my parents and school. Back then I had no idea that I would grow up to study and work along this enigmatic structure. Now, when I was asked for my favourite place, the one I immediately thought of was looking west from Birdoswald fort, watching the sunset after a (rare for Cumbria) hot summer day.

On the top of the slope stands a sole tree marking the line of the Turf Wall, the precursor to the Stone Wall. Directly in front of the tree, you can clearly see the profile of the Turf Wall ditch running down the slope towards you. Behind the tree to the south, a now gentle dip in the land marks the line of the Vallum. The Stone Wall remains run to the north along the trail and road.

I've been lucky enough to live and dig at Birdoswald over the summers with the Newcastle University and Historic England excavation project, 2021-2024. The excavations are discovering what happened to this area when the Turf Wall was dismantled and the new Stone Wall built to the north. To me, this view is not only a relaxing place to be after a long day of digging, but also encapsulates the changes to the frontier and life of the Wall.

The Moneyholes

Rachel Newman

The Moneyholes, so called because there is a legend that a hoard of Roman coins was found there, is situated at the top of Craggle Hill, in Wall Mile 53, west of Banks village in Cumberland. It is in a part of the Wall less travelled: indeed, this area was only used by the occasional dog-walker before the Hadrian's Wall Path National Trail opened in 2003. The Wall is not visible in the way that it is in the central sector, being marked only by a field boundary, though this is clearly ancient, built largely of Wall stones, and in the medieval period formed the northern side of the precinct of Lanercost Priory, which is nestled in the valley bottom. Nor does Craggle Hill have the same majesty as the high points of Wall Miles 34-45, as at Mucklebank, or Winshields.

What it does have, however, is a panoramic 360° view, stretching from the Bewcastle Wastes to the north, round through the top of the Solway Firth, to the Lakeland Fells to the south-west, and on to the Geltsdale Forest on the south side of the Irthing Valley, with hints to the east of the high hills of the central sector. It is, in Wall terms, at the point where the uplands end, and the lowlands of Carlisle and the Solway begin. In other words, the landscape has begun to soften; there is a warmth to it, in all seasons but the winter, and it feels very different from that to west and east. Archaeology is all around you, prehistoric, Roman and later, but it is subtle: you have to look for it, rather than it being in easily visible, as it largely is from Banks to the east side of the Tyne. In places, the core of the Wall is still visible (as to the west, in Wall Mile 54), though the facing stones have gone, demonstrating how fragile a once-dominating structure can become, when not protected by a major institution, such as English Heritage or the National Trust.

Cam Beck

Rob Collins

The fort of Castlesteads is now largely invisible to the modern visitor of the Wall, surmounted by the walled garden of Castlesteads House. But at Castlesteads, the fort is detached from the Wall curtain, which ran to its north. At this location, the Roman builders of the Wall faced a challenge – how to carry the Wall across a reasonably minor river, the Cam Beck. The beck runs in a general north-south course, winding its way between hills, and across 1000s of years, has carved a short gorge to the north of Castlesteads. This gorge is where the Wall crosses the beck.

For the contemporary visitor, the location of the Wall at Cam Beck, here seen from the east, captures an idyllic English countryside, with the gentle flow of the beck through a leafy woodland that has bountiful bluebells each spring. A crescentic weir creates a pleasant fall for the water, and the visitor is surrounded by birdsong with the gentle baa-ing of sheep filtering through the trees from the pasture to either side of the beck. The visitor can follow the path of the National Trail from east or west, down the wooded side of one embankment, across the modern footbridge, up the other bank, and exit into the next pasture, enjoying this small localised paradise.

The discerning visitor, however, will also note the remaining evidence for the ditch to the north of the Wall curtain, visible as broad V-shapes in both the east and west banks. The weir has a slipway at its western end which reused Roman stones from a now lost bridge. And recent excavations revealed the much robbed but telltale traces of Roman archaeology. Originally, the Wall was built in turf at this position, and the excavations revealed the corner of a tower positioned just south of the Turf Wall, presumably to provide soldiers a view into the 10 m deep gorge. The Turf Wall, however, was replaced with the Stone Wall and with it a new tower positioned where the curtain intersected the eastern bank of the gorge of the Cam Beck, with evidence for a set of stairs or perhaps a ramp that provided access up to the tower and onto a pedestrian bridge across the beck.

The Disappearing Ditch at Houghton, Carlisle

Susan Aglionby

Having had a view of the ' disappearing ditch' and its northern bank from my bedroom window for 32 years, I had a hankering to own this tiny fragment of Hadrian's Wall. The opportunity to purchase the 23-acre field through which the ditch and bank run came up in 2020. This field adjoins my farm on two sides, so agriculturally would be an asset to the farm. The farm is now 'Susan's Farm' a registered charity, a Care Farm, undertaking work with some of the most vulnerable in our community as well as having an extensive educational programme. It was important to me that those who visit the site are able to understand what they are looking at. I was determined that high quality interpretation boards should be erected.

I was advised by Henry Summerson, a mediaeval historian, to approach David Breeze. This I did and we found we had many connections. He suggested we also work with Mark Richards, the illustrator, who I already knew. I have enjoyed working in this small team to enable the many visitors to the farm to understand what they are looking at! The culmination was the erection of an interpretative panel. My family, I am pleased to say, would like to retain the ownership of this field. …and the 'disappearing ditch'? The ditch (left) was dropped from maps but has now been re-instated.

Hadrian's Wall

In AD 122 the Roman Emperor Hadrian visited Britain and according to his biographer ordered the building of a wall 80 miles long from sea to sea. The east end of this Wall, Hadrian's Wall, lay at modern Wallsend and the west end at Bowness on Solway. Most of the Wall was of stone, but the western 30 miles (48 km) was of turf. In front lay a wide and deep ditch with its contents tipped out to the north to form an upcast mound. At every mile there was a 'milecastle', a small enclosure containing barracks and protecting a gate through the Wall. In between each pair of milecastles were two towers, called turrets, for observation. During building work forts were added to the Wall. This Roman was still in use when Britain ceased to be part of the Roman Empire about 410.

The Turf Wall
The original Wall here was of turf. It is possible that there was a walk-way along its top protected by a

The Stone Wall
Some decades after its construction the Turf Wall was demolished and replaced in stone. This narrower wall is shown with a sloping top as it was probably too narrow for a walk-walk.

Medieval Droveway
The substantial bank visible immediately north of the ditch and sitting on top of its upcast mound is a much later road. In places, fragments of the hedges which formerly lined it are still visible. This is probably a drove road along which animals travelled from farms to towns and villages

Burgh Marsh

Humphrey Welfare

At Drumburgh, the Roman fort was built on the summit of a glacial drumlin: although only 20m above the sea, it provides an extensive view eastwards along the Wall, which also formed the north side of the fort. To the south stands the great 14th-century house of Drumburgh with, far beyond, the northern Fells. To the north, the horizon is punctuated by the unmistakeable profile of Burnswark, overlooking the confluence of the Esk and the Eden – where the Solway begins. Ahead, to the east, the north Pennines. For the first 4 km the line of sight is across Burgh Marsh, the defence of which was probably the garrison's principal focus: the very name of the fort was *Congabata*, which means 'scooped out' or 'dish-like', a good description of this expanse of estuarine grassland and saltmarsh. Here, between milecastles 73 and 76, we have no evidence whatever of the form of the frontier. Despite being drained, the marsh still floods every year and so it is likely to have been a natural barrier, augmented perhaps by a palisade but more probably guarded, like the coast between Bowness and Maryport, by milefortlets and towers on the drier ground, not connected by any Wall. Such gaps in our knowledge fire the creative imagination in archaeology.

Bowness-on-Solway

Andreas Thiel

I owe my first, more detailed knowledge of late antiquity and the early Middle Ages in the British Isles to my intensive reading of the adventures of Prince Valiant, written by the American Harold R. Forster. Some colleagues say that this childhood influence is still noticeable in me today - they are probably right.

In any case, Prince Valiant, the Prinz Eisenherz in the German translation, took me to Hadrian's Wall, among other places, when I was a boy. The relevant story by Forster was published in October 1942, and is about Prince Valliant traveling north on behalf of King Arthur to see if the old Roman Wall can be repaired (Harold R. Forster, 'Prince Valiant in the days of King Arthur', 4 October 1942, 295). Once there he meets a certain Julian, a descendant of the Roman troops who left the province half a century earlier. Julian, who took over the duty of guarding the Wall from his ancestors, serves as Valiant's guide. Together they cross the north of England and finally reach the Solway, where both the buildings of Maia fort and the stone rampart are still standing in full height at the legendary time in which our story is set.

Under the impression of the dramatic landscape that Forster portrayed, my first visit in the winter of 1990 was admittedly sobering. The Scottish mountains north of the Solway were a little further away than my author had portrayed them to me and - well, we don't need to talk about the remains of the rampart in this section that still exist today. Despite these unfortunate facts of today, I still find it fascinating to think about how 'the beginning' of the coastal fringe was created! Did the Wall start abruptly, did it gradually get higher, was there a special marker, was the finish monumental? I have been at Bowness six or seven times in total so far and, after my initial disappointment that 'the beginning' is not elevated and the landscape was different, I was nevertheless always fascinated by the vast marsh landscape and the proximity of the northern shore. By the way: the highly dramatic story about Valiant's second visit to Hadrian's Wall was published in September 1949. It was a pity that he missed the first International Congress of Roman Frontier Studies, which had taken place just a few weeks earlier, and its participants missed the chance to benefit from our hero's knowledge.

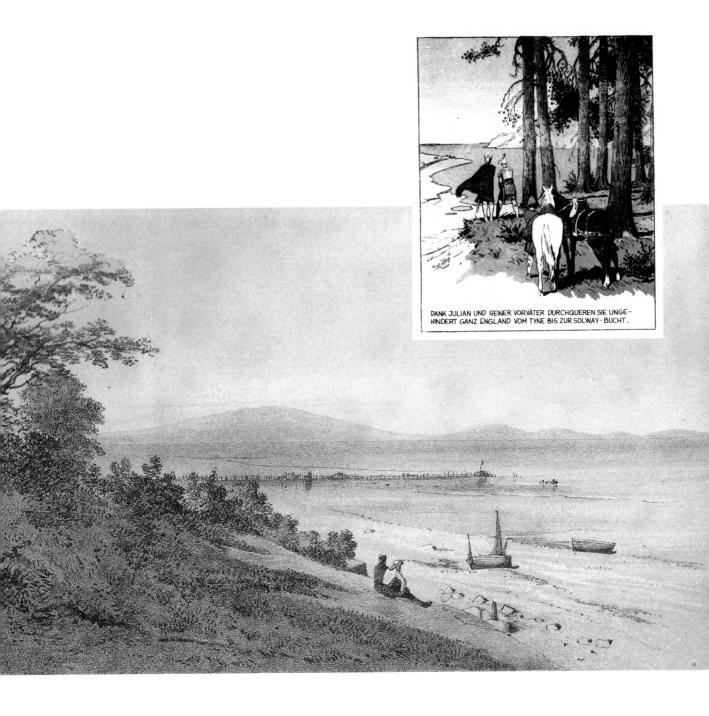

DANK JULIAN UND SEINER VORVÄTER DURCHQUEREN SIE UNGE-
HINDERT GANZ ENGLAND VOM TYNE BIS ZUR SOLWAY-BUCHT.

The Cumbrian Coast

Criffel from Maryport

Pete Wilson

Despite being someone who has never actually worked on 'The Wall' I have had a long and varied association with this most iconic of monuments and its hinterland, both through previous professional incarnations and, inevitably, as a frequent visitor. Choosing an image to represent those decades of association proved challenging, particularly as many other colleagues had more obvious 'claims' to many locations. In one way or another I have been associated with Maryport for some twenty years and, until relatively recent interventions, the limited extent of modern archaeological research had in my mind served to create a mystique driven in large part by its liminal location above the Solway. Looking across the water, particularly in misty conditions or as evening falls, produces a sense of 'otherness'. Criffel, across the Solway, was at different times within the Empire and part of 'Barbaricum' and the nature and extent of Roman contacts with and influence in Dumfries outside periods of active campaigning and occupation is unclear. That the forts and associated works on the Cumberland Coast were deemed necessary is certain – what they faced, or guarded against less so. What at different times might have been expected to possibly emerge from the mist?

Milefortlet 21 (Swarthy Hill)

Jane Laskey

Both living and working in Maryport, life is dominated by the view across the Solway Firth towards the Dumfries coast, with Criffel appearing to rise out of the sea. This is the same view the Roman occupiers would have seen as they kept watch from the forts, fortlets and watchtowers guarding the frontier between empire and barbarian. They would have seen the same rain showers driving up the firth and the same glorious sunsets that we see now. Walking along the beach north from Maryport you can imagine the landscape unchanged and yourself treading in their footsteps. The majority of the frontier is invisible here, only revealed as crop marks in a dry summer or a small mound beneath the golf course. The exception is milefortlet 21 near the summit of Swarthy Hill, two miles north of Maryport. This timber fortlet was excavated over thirty years ago revealing the ditches, ramparts and buildings where a small detachment guarded the frontier. Here you can imagine how they lived in the small buildings with only a meagre hearth to keep them warm and cook their food, the tedium alleviated by eating, drinking and gambling. The fort at Maryport is visible from here. On those cold nights watching the pin-pricks of enemy fires across the firth, did they look longingly south towards the bright lights of their garrison fort on the skyline?

Soldiers and Sweethearts

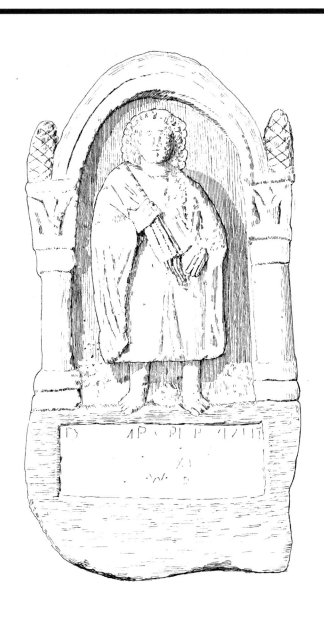

The Tombstone of Flavinus, Hexham Abbey

Ian Haynes

My choice is something of a cheat; my choice of favourite place keeps changing, and I have not selected a view in a conventional sense. I feel, however, that Flavinus' tombstone warrants a special mention (*RIB* 1172). Flavinus, standard-bearer (*signifer*) in the troop of Candidus of the *ala Petriana*, died a couple of generations before Hadrian came to power, but his monument evokes something of the might, pride and bloodshed underpinning the Wall's story.

By any standards this 2.64 m funerary marker is imposing. In its original colours it must have been even more striking, an eloquent witness to the aspirations and status of the man and his regiment. The *ala Petriana* became the largest cavalry regiment in Rome's army of Britain. Twice normal size, an *ala milliaria*, a thousand strong, it was a strategic asset. When Flavinus died, the *ala* was still at Corbridge, but following the construction of the Wall it moved to Stanwix near Carlisle and gave its name to that fort.

Digitally scanning the stone in the medieval grandeur of Hexham Abbey, where it had once been repurposed as a foundation stone, was its own journey in time. The resulting fine image of rider, richly adorned horse, battered barbarian, and revealing epitaph, presents anew the force of the encounters that shaped the frontier landscape.

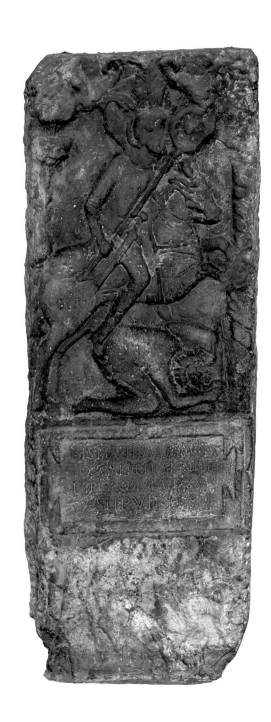

A Standard Bearer from Carrawburgh

Eckhard Deschler-Erb

The Roman fort of Chesters (*Cilurnum*) with the nearby remains of the Roman bridge over the North Tyne is one of my favourite places on Hadrian's Wall. In the park belonging to the fort, the Chesters Roman Museum, opened in 1896, houses the Clayton Collection of Roman antiquities, a wonderful assemblage of Roman stone monuments and other objects gathered by John Clayton (1792-1890) during decades of excavations along Hadrian's Wall. Right in the entrance area, visitors come across the tombstone of a standard-bearer (*signifer*) from Carrawburgh (*Brocolitia*), another fort on Hadrian's Wall, occupied by various infantry units from Hadrianic times until the beginning of the 5th century.

The stone shows a standing 3rd century soldier, dressed in knee-length trousers, a long-sleeved tunic and girded with a ring-buckled belt (*cingulum*). A long sword (*spatha*) is attached to a balteus on the left side. The soldier holds a shield with curved sides in his left hand and a standard in his right. This is crowned with a bull pointing to the left and ends with a trident, probably to ensure a firm stand in the ground. Unfortunately, no funerary inscription has survived, but the soldier could belong to the First Cohort of Batavians stationed at Carrawburgh in the 3rd century

This standard-bearer, proudly depicted with the insignia of his rank, can be said to represent all the men who secured the frontier of the empire in the name of Rome for several centuries.

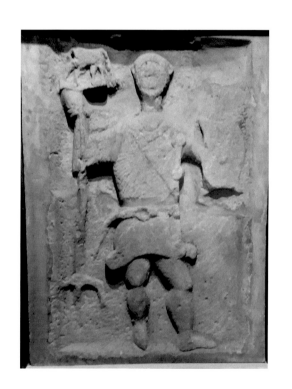

The Corbridge Hoard of Armour

Jon Coulston

The most important find of the 1960s excavations at Corbridge was 'The Corbridge Hoard'. It was not fully published until the magisterial work of Lindsay Allason-Jones and Michael Bishop in 1988. A large chest had been filled with a puzzling variety of artefacts with sections of the iconic form of Roman body-armour, the so-called '*lorica segmentata*'. Although artefactual evidence was already available at the beginning of the 20th century, it took the Corbridge find to concentrate the minds of Charles Daniels and H. Russell Robinson to reconstruct how segmental plate armours were constructed and functioned. I first became aware of the Hoard directly during a trip along Hadrian's Wall with my father in 1974 where I saw Robinson's reconstructions mounted on mannequins in the Museum of Antiquities, Newcastle. By that time I was already obsessed with the Roman army in general, and in Trajan's Column in Rome, still then the principal iconographic source for Roman military equipment. Charles Daniels became the supervisor of my PhD on the Column, and we talked often of the Corbridge excavations and the armours. Thereafter, the Corbridge Hoard has never been far from my thoughts as the field or Roman military equipment studies burgeoned. Of course, the Hoard itself has far-reaching importance for Roman frontier archaeology, not least in revealing the practices of the army when it dismantled installations and disposed of material which would otherwise have been repaired and recycled. It is most likely that the chest was filled with the sort of 'might come in useful one day' items which accumulate at the backs of modern garages, but, perhaps because there was no more room in the back of the last departing cart, it was decided to bury it to save the hassle.

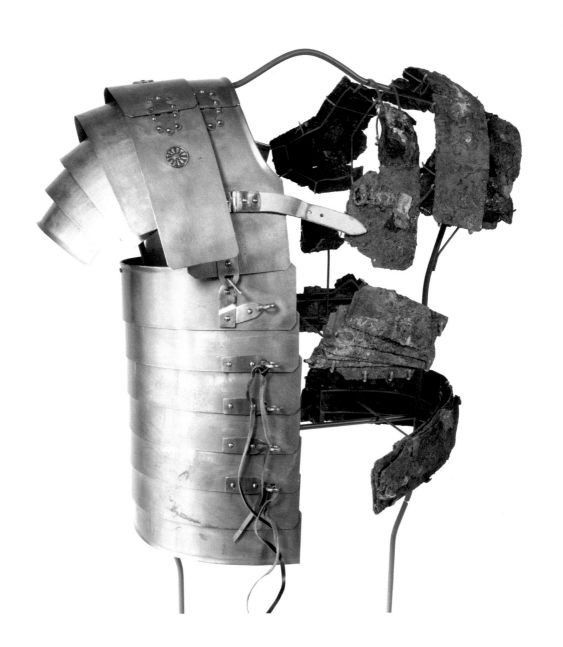

A Curious Item of Headgear from Vindolanda

John Peter Wild

Flavius Cerealis and his wife Sulpicia Lepidina are famous for the rubbish they left behind in the Period III *praetorium* at Vindolanda. One thinks primarily of the leaf-tablets: but in this note the focus is on a much humbler object: a conical cap of hair-moss, discarded or overlooked when the garrison was redeployed to the Danube in 104 or 105.

Hair-moss (*polytrichum commune*) grows abundantly on the boggy uplands of northern Britain, where its stems, dried and defoliated, can be used for basketry. The cap itself is constructed on a skeleton of six radiating ribs, bundles of moss stems projecting from a central peak. Into each segment between the ribs further bundles were fed and secured by 'active' strands worked round the peak. Just before completion single moss stems were anchored into the cap's edge to form a fringe, up to 28 cm long.

The only, near-contemporary, parallel from Newstead was identified by James Curle as an unfinished basket; but two unfinished baskets would be rather a coincidence! While there is a consensus that the Vindolanda object is a head-covering, beyond that ideas vary. 'Interesting – and curious' Ian Richmond would have called it. Could it be a wig? But it does not resemble the wigs of Ancient Egypt, let alone a fashionable Trajanic coiffure. A rain-hat perhaps? Only the fringe might shed water like a thatch: the central 'cap' would absorb it. Could the fringe be designed to repel midges? Wild-fowling and fishing feature in *Tab.Vindol.* III, 593 as pursuits where such protection might be appreciated. Here the cap's outlandish appearance might be forgiven.

Perhaps an exact replica of the cap could be created by an experienced basket-maker and the various hypotheses tested in the field. Had Cerealis and his friends discovered an age-old Geordie secret?

Ink and Tablets from the Frontier

Andrew Birley

A picture may be able to tell a thousand words, but an ancient letter is more than a picture, it is a view and a window into the very mind and soul of the human being who wrote it.

The Roman frontier was once dominated by organics which included people, animals, textiles, leather, refuse and wood. While nearly all those things are forever lost a precious few letters remain buried below the soil, each a capsule filled with new knowledge, perspectives, and views from a time which for many can seem impossibly distant from our modern life and times.

The letters were either created on locally growing wood, oak, birch, and alder or were created by carefully recycling imported objects like barrels, wagons, and floorboards. Their skilled manufacture turned living organic material into an embodiment of human expression. The names from the tablets give us the first Romans of the frontier, people like Verecundus, Masclus, Lepidina, Tagomas and Candidus. They allow us to imagine what it would be like to have met them when we make our own journey along Hadrian's Wall. Their fragile nature reminds us of the fragility of life itself and the distance in time they have travelled ignites our imaginations in a way few other objects are able to.

The Tombstone of Regina at South Shields

Maureen Carroll

My contribution to reflections on Hadrian's Wall focuses on the tall Roman gravestone of a British woman named Regina who died in the second half of the 2nd century at the Roman fort of *Arbeia* (South Shields) and was commemorated by her husband Barates from Syria. The monument illustrates beautifully the ethnic diversity and physical mobility of people in the Roman empire, particularly in bustling locations such as the mouth of the Tyne where goods and people flowed into the region. It also reveals important details about the personal history of 30-year-old Regina, her relationship with Barates, and how they saw themselves and wanted to be remembered. She came from south-east Britain and was once his slave until he granted her freedom and then legitimised their union by marriage. He came from the great oasis city of Palmyra in the Syrian desert. If he is the same Barates whose tombstone was found at Corbridge, this man possibly was a Syrian merchant. Two languages appear in the epitaph chosen by Barates, Latin and Palmyrene Aramaic. This underscores cultural diversity on Hadrian's Wall. Epitaphs were meant to be read, indicating that other Aramaic speakers were present to do so. The sculptor himself may have been Syrian, as the confident letters in the Aramaic inscription and various details in her portrait suggest. Regina is dressed in the Roman clothing of Britain, resplendent with jewellery, and she holds a spindle and distaff to deliver the message that she was skilled in wool-working, as Roman matrons ideally were. This iconic monument, therefore, signals important information about migration, ethnicity, social standing, and gender relationships on Rome's northern frontier.

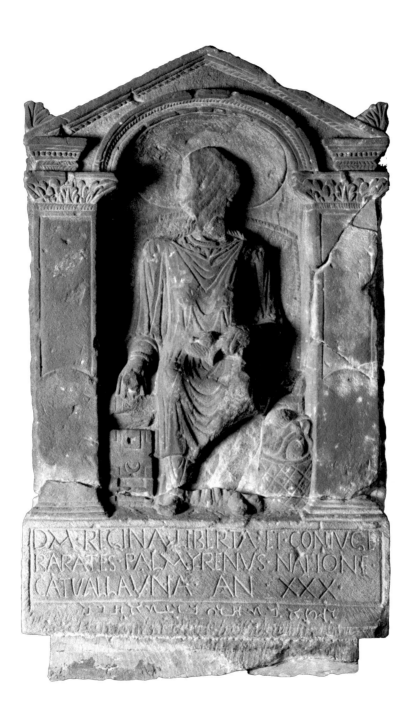

D M REGINA LIBERTA ET CONIVGE
BARATES PALMYRENVS NATIONE
CATVALLAVNA · AN · XXX

Religion on the Wall

Gods for Natives and Romans on Hadrian's Wall

Emanuela Borgia

I started working on Hadrian's Wall in 2017, when the collaboration project between my Department (Sciences of Antiquity) of Sapienza University of Rome (Italy) and Tullie House Museum & Art Gallery Trust of Carlisle took its first steps. The project is still on-going, and my interest in Roman frontiers is increasingly growing. From the very first moment my attention was drawn to Celtic deities that were peculiar to the Wall's area and beyond. Some of them are unique, being totally unknown elsewhere (e.g. Belatucadrus, Cocidius, Maponus, Mogons). Small altars, inscriptions, votive plaques, figured reliefs testify that the worship of these typically local gods, frequently connected to very specific sites, was practiced not only by natives, but often by Roman soldiers too. The military, even if devoted to the 'official' gods of the Roman pantheon and to those of their regimental homelands, were attracted by autochthonous deities, maybe looking more suitable than others to protect them. This is the testimony of how native British culture and divine identities had gained influence within the international and multicultural context of Roman Britain. Therefore, the integration between different cultures in common and religious life seems to have succeeded also on the very far northern boundaries of the Empire.

The Temple of Antenociticus at Benwell

Lindsay Allason-Jones

For visitors used to imagining Hadrian's Wall as it crosses the rugged scenery of the Central Sector, it may be a shock to turn into a 1930s estate of semi-detached houses in the western suburbs of Newcastle and find a Roman temple in a garden.

The temple in Broomridge Avenue, Benwell, has been known since 1862 when the landowner, engineer and naval architect George Wightwick Rendel excavated the site. He uncovered an apsidal building with three altars dedicated to the Celtic deity Antenociticus, as well as the head and a limb of a cult statue. One of the altars was dedicated by the First Cohort of Vangiones; the second was dedicated by Aelius Vibius, a centurion of the Twentieth Legion Valeria Victrix, who linked Antenociticus to the Deities of the Emperors. The third altar was dedicated by Tineius Longus who, 'while prefect of cavalry', had been adorned with the (senatorial) broad stripe and designated quaestor'. This was a peculiarly Roman ambition and why he thought this deity, who is only known at Benwell, had enough influence to ensure he was successful, we will never know.

The site has facsimile altars *in situ*; the original altars and the head of the deity are on display in the Great North Museum at Newcastle University.

Temple of Mithras at Carrawburgh

David Walsh

In Antiquity, the landscape around Hadrian's Wall was littered with sacred buildings and spaces, but today few are as evocative as the temple of Mithras at Carrawburgh. This is the only extant mithraeum along the Wall, although evidence indicates the cult was popular at several sites. When the temple at Carrawburgh was constructed, entering the windowless mithraeum would have felt like descending into a cave; today, with the walls only several courses high, a visitor is open to the elements (and the occasional friendly sheep). Yet with the Military Road largely hidden behind the bank where the fort once stood, and the landscape stretching into seeming emptiness, there remains a sense that the mithraeum is a space that still provides a connection to the otherworldly. So much so, that at the end of the central nave, which is flanked by two grassy banks where benches would once have stood, sit three replica altars that still attract a myriad of offerings. Some items have come from people rifling around in their pockets on a whim, but some — bunches of flowers, painted stones, jewellery, and even the occasional ceramic Mithraic icon — demonstrate that for many there is a sacredness to the site that remains as potent as ever.

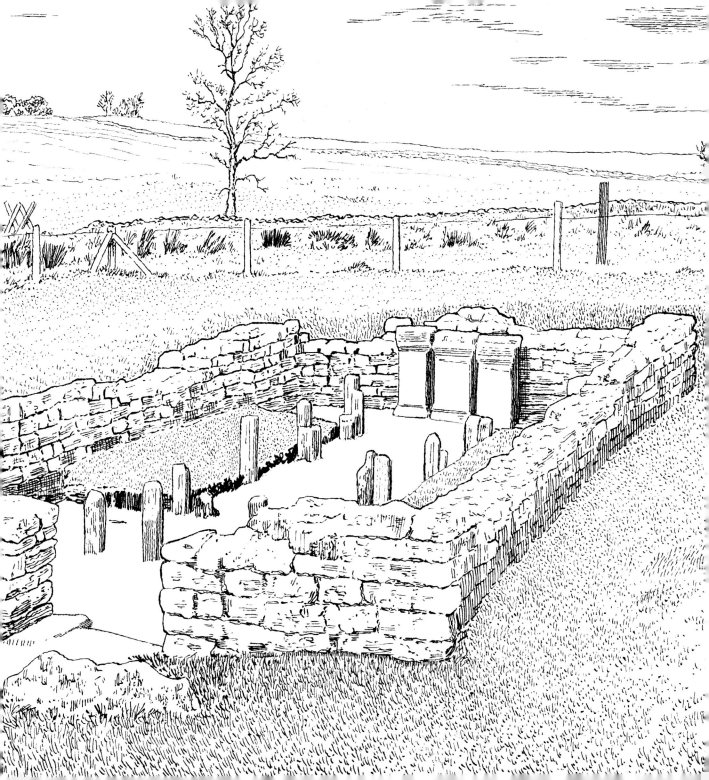

The River God at Chesters

Richard Hingley

One of the most evocative sculptures from the Wall is that of the river god found at the fort of Chesters (*Cilurnum*). There are several sculptures of river gods from Britain. This example, which can be studied in the museum at Chesters, is unusual since it is almost complete and relatively undamaged. Found in 1843, during John Clayton's excavations at the fort, it had been deposited in a breach in the northern wall of the bathhouse that lay inside the fort.

This river god is shown reclining with flowing hair and a long beard. This is a standard pose for a river god, comparable to the much more imposing figure of the river Danube at the base of Trajan's Column in Rome. The Chesters sculpture is, however, of particular interest since it depicts a double deity. Just to the bottom right of the reclining river god is the head of a second larger bearded and long-haired god. Significantly, the statue was found in one of the two bathhouses at Chesters since these buildings were supplied with water from the river North Tyne, which flows 100 m east of the find spot. The reclining water god must represent the spirit of the North Tyne, but who is the god represented by the larger head? Could this be Oceanus, the god of the sea in Greek mythology, who was seen as the father of all water sources? Or could this be the river Tyne itself? The location at which the North Tyne meets the South Tyne lies 4km south of Chesters.

Water in all its forms was worshipped on the Wall, as we know from several other discoveries, including the altars dedicated to Oceanus and Neptune from Hadrian's Bridge at Newcastle and the temple and dedications to the spring goddess Coventina at Carrawburgh, the next fort to the west of Chesters.

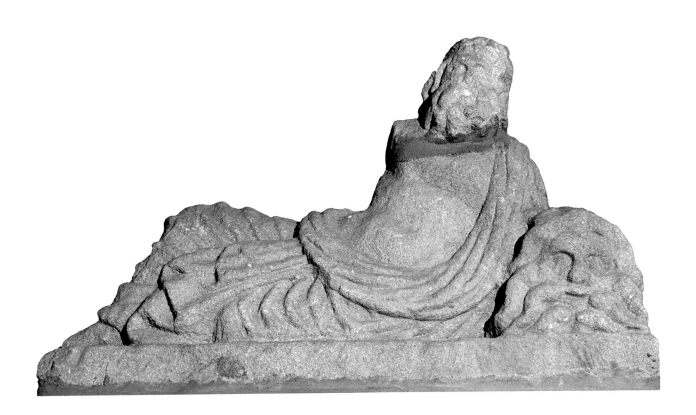

Communications

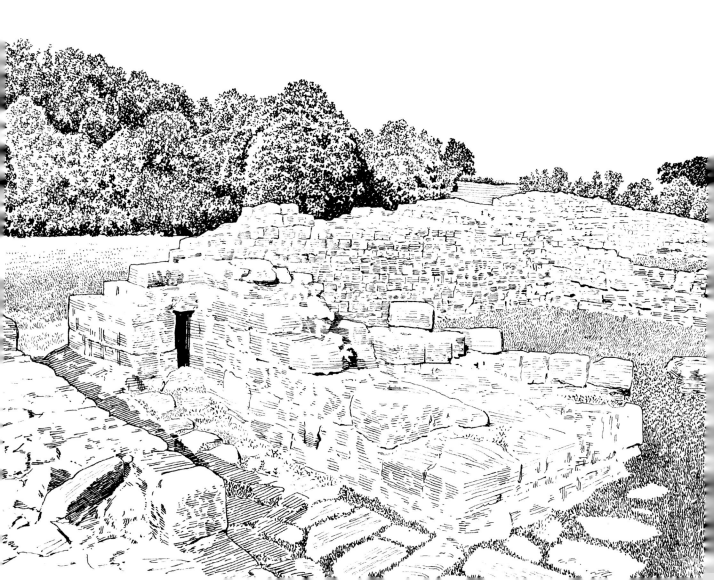

Westgate Road, Newcastle

Don O'Meara

Though the rural, central section of Hadrian's Wall is idyllic and iconic, I feel the view which truly captures the spirit of the Roman construction is to stand on the traffic island at the intersection of Neville Street, Westgate Road (to the right), and Collingwood Street in Newcastle City centre. (NZ 24806 63958). From here a Roman citizen could marvel at how a relatively small fort defending a bridge crossing the River Tyne would become the largest city for 100 miles, and a major city in the industrialisation of the British Empire.

This position is also a clear example of how Hadrian's Wall has had a lasting impression on the development of the urban layout. From this point the Hadrianic line of Westgate Road extends north-west, beyond the horizon until it reaches the remains of Benwell/*Condercum* fort (where the Vallum crossing and the temple of Antenociticus can be seen amidst a 1930s housing estate). Turning to the south a 2nd century observer would have been standing near the fort ditch, looking up at the Wall near what is now the entrances to the Lit & Phil Library and the Mining Institute. South-east along Westgate Road the viewer would see the Wall meet the location of the Roman fort and civilian settlement, now under the Castle Keep and railway arches. To stand here is to appreciate Hadrian's Wall not as bucolic and rural, but the urban and bustling setting that was such a key cultural element of the Roman state and society.

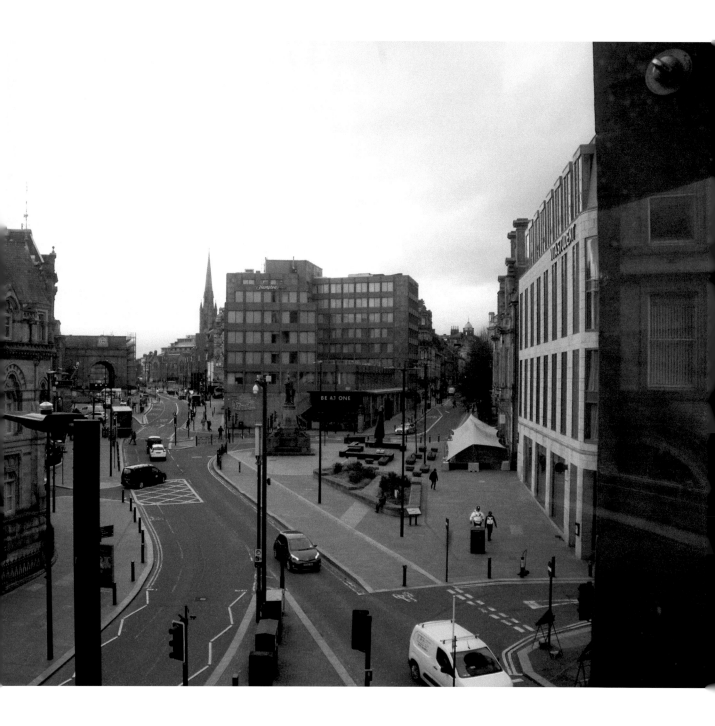

The Military Road

Robert Witcher

The Wall is a monument to see and to see from. Standing on the crags of the central sector, one's eye is drawn as much to the expansive landscape views as to the zig-zagging Wall itself. Many visitors imagine themselves as Roman soldiers gazing out beyond the empire, their thoughts and actions guided by our cultural familiarity with the Roman past. For this is a monument we have already experienced before our first-ever visit thanks to the iconic images engrained in the popular imagination.

Yet, my favourite view is not of the Wall but of the journey to it. Unless walking from end to end, a visit inevitably means travelling along the B6318—the Military Road. Not to be confused with the Military Way (the Roman road that served the line of the Wall) the Military Road was built in the aftermath of the Jacobite rising, a response to General Wade's difficulties in quickly moving his troops from Newcastle to Carlisle. The road's course closely follows the line of the Wall; indeed, for long stretches, it uses the stone curtain wall as a foundation.

To arrive at the Wall, I drive up the A68, turn left at the Portgate and join the Military Road. Heading west, I snatch precious glimpses of the Vallum and the Stone Wall; but it is the Military Road that demands my attention. I cross the bridge at Chesters. Until a few years ago, an old roadside sign here proclaimed 'B6318 The Roman Wall'—an appellation now almost entirely eclipsed. I lament its loss. On another day, I drive via Haltwhistle and join the Military Road next to the Milecastle Inn. The signs direct me left towards the open skies of the Solway Firth or right, back home; instead I head straight on to Cawfields, put on my boots and strike out along the Wall.

The Hadrian's Wall Trail

David McGlade

This photograph taken in Wall mile 30 is an east-bound view approaching, in the distance, Limestone Corner. As the first Hadrian's Wall Path National Trail Officer, in post between 1995 and 2017, my favourite view of Hadrian's Wall is anywhere with a sustainably managed grass sward path underfoot. This image sums up perfectly how proactive grassland management can be used to influence visitors without them realising that they are being managed. The aim, of course, is to protect both the setting of the World Heritage Site as well as any near surface archaeology and the walkers are seen here walking side-by-side on an unbroken grass path, recently mown to two metres width, with no sign of any wear lines or bare soil.

In 1994 the Secretary of State approved the creation of a Hadrian's Wall Path with the condition, enshrined in the Countryside Commission's 1993 Submission Document to the government, that: 'The most appropriate footpath surface is a green sward path. This will be aimed for wherever practical, using vegetation management techniques as part of a regular maintenance regime.'

The green sward aim influenced just about every waking moment of my time on the Wall because the cost of not enacting a well-funded maintenance regime, erosion, is well documented from Hadrian's Wall and beyond. While grass is a very sustainable medium and will quite happily continue to grow it has a carrying capacity which changes from season to season and from year to year. Wet winter soils will sustain the pressure of far fewer people than can dry summer soils but, as a Public Right of Way, Hadrian's Wall Path is open all year round to Trail users, day visitors and local alike. We introduced the seasonal Passport in an attempt to influence the majority of Trail users towards the spring summer and autumn seasons when, in a normal year, the World Heritage Site's soils are drier. We also coined the conservation tip which asked all visitors to walk side-by-side instead of in single file because that way the green sward path's carrying capacity is doubled, and it costs nothing.

The green sward remains the underpinning aim for everyone concerned with the management of the World Heritage Site but as our climate changes our understanding of a normal year for precipitation, soil moisture and visitor carrying capacity, may also need to change along with how the green sward path is to be managed.

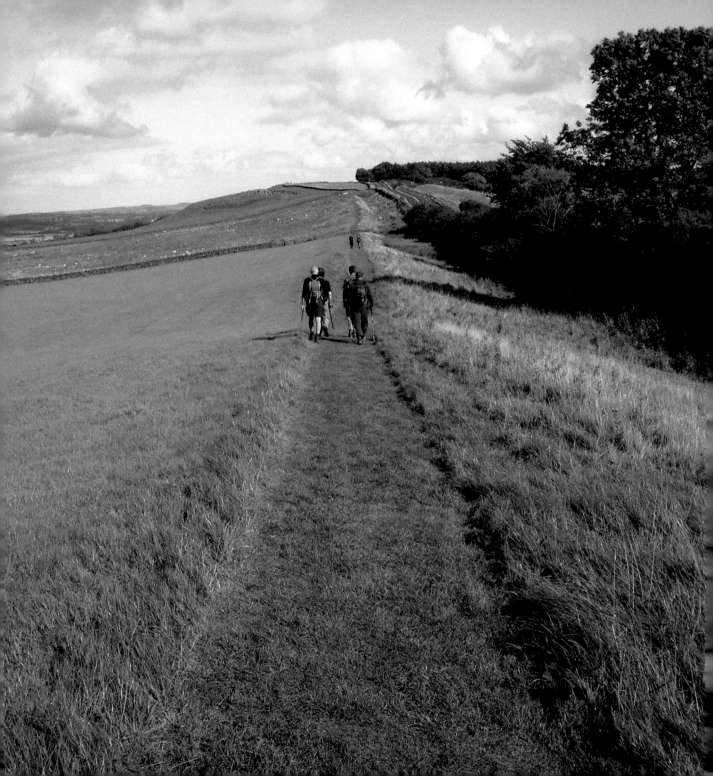

Beyond the Wall

Burnswark

Alan Wilkins

Even from 20 miles (32 km) away, the long flat-topped lava flow of Burnswark Hill dominates this view from the line of Hadrian's frontier close to Bowness-on-Solway. On clear days it is a frequent northerly marker for travellers Roman and modern from Winshields to Bowness. West of there Burnswark and Criffel command the view. Today, while waiting at the traffic lights at Stanwix, Carlisle, with the house plaque on the left marking the line of the Wall, we are in the very spot where Hadrianic and later Romans emerged through an impressive gateway in the Wall to begin their journey north. Burnswark would be the marker for their direction of travel, because the surveyors had aimed their road at the Hill's left shoulder. After a night spent in the facilities of the well-defended annexe to Birrens fort, travellers would soon reach the Hill. Does the fort's name, Blatobulgium ('the flour sack') come from its shape? Today, park at the T-junction, walk to the field-gate, and admire the remarkable size and preservation of the Roman South Camp and the Three Brethren artillery mounds at its entrances well up the Hill's slope. From the summit, spot the site of Bowness Wall fort and enjoy the north-south vistas of the Annan valley; but remember that the view for the Iron Age inhabitants was the ominous arrival of the invasion fleet of Agricola, governor of Britain from 77 to 83.

Epiacum (Whitley Castle)

Mark Richards

As an inveterate walker and pen artist, imagining heritage landscapes has been a constant fascination. For more than thirty years I have been drawn to explore Hadrian's Wall, while constantly my eyes have cast with growing curiosity to its wider setting. Hence my fascination in Whitley Castle, enigmatically perched above Castle Nook Farm, near Alston. My farming roots making me at home on these windswept pastures, grazed by flocks and herds long before the legions came. Mercifully, *Epiacum* remains unexcavated, its treasures undisturbed beneath the damp Pennine turf.

The passing Maiden Way took a strenuous course over the watershed from the York to Carlisle road at Kirkby Thore (*Bravoniacum*). The Romans were intent on resourcing the silver and lead buried deep within the South Tyne valley. The fort lay a day's march south of Carvoran (*Magna*) on the frontier. Tempting to think the Brythonic place-name Carvoran 'fort of the maidens' is reflected in the Roman road's enduring name.

Castle Nook is to be applauded for engaging in the establishment of Epiacum Heritage Ltd to protect the site for the future - with an interpretative trail and tearoom to welcome visitors - nurturing an understanding of the long history of this truly remarkable monument.

Heavenfield

David Petts

The church of St Oswald in Lee lies close to the line of the Wall, just to the north of turret 25b. Nestling in a clump of trees, it is skylined from the passing road; it is only when you cross to the field that commanding views across the North Tyne and Erring Burn are revealed; from here it is possible to see Carter Bar, Simonside and the Cheviot. The site owes its importance not to the presence of the Roman military, but rather as the location of the important Battle of Heavenfield. Bede recorded that the new king of Northumbria, Oswald, faced down his British rival Cadwallon here (c. 663/4). By the time he was writing, in the 8th century, the location had become knitted into a new Christianised landscape – a church had been built, and monks from Hexham visited on an annual pilgrimage. Fragments of a simple Anglian cross shaft lie in the porch, whilst in the church stands a Roman altar that has been reused as a cross-base. Although this is clearly not related to the simple wooden cross that Bede says Oswald erected on the eve of the battle, it is testament to the attention being paid by the Northumbrian church to this relatively isolated site. By the time of the battle, the role of the Wall as a linear defence had long gone; although in his description of the site, Bede described it lying close to the church. His description of the Wall as being built 'to keep off the attacks of the barbarians' would have had resonance for those remembering Oswald's defeat of a hostile British army. The proximity to Dere Street, which survived as a major routeway in this period, is important. Even in this period, the Roman road network provided an armature for the landscape and must surely have been used by Anglian and British armies as they campaigned in Northumbria. The Wall, the settlement at Corbridge and nearby bridges would all have acted as sources for stone, not only for the early church of St Oswald, but also the churches at Hexham and Corbridge. At Heavenfield, the physical and symbolic legacy of the Roman frontier and its infrastructure would have loomed large for the Anglian population, centuries after the withdrawal of Roman imperial government. It is a potent reminder of how every generation has reworked and remade the Wall to reflect their own concerns and interests.

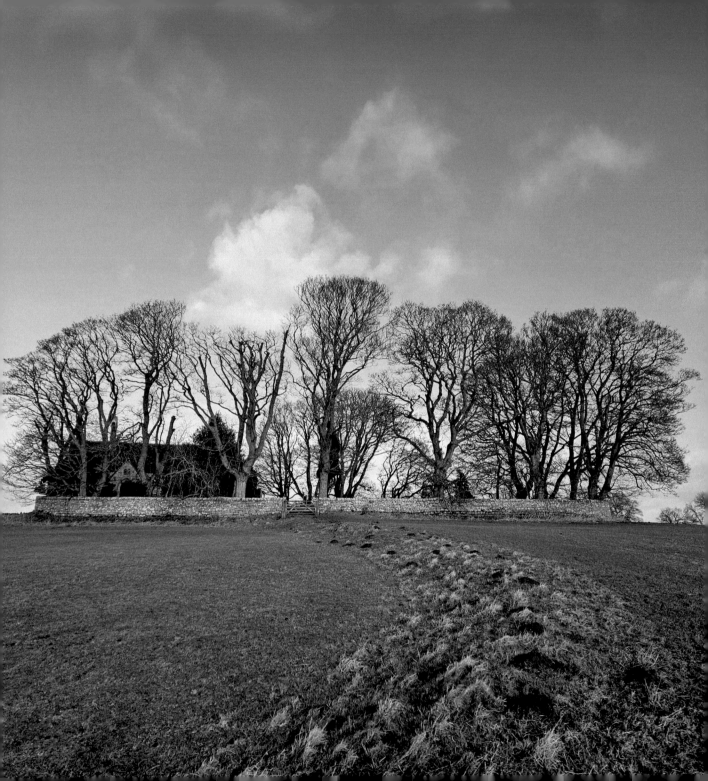

Antiquarians and Archaeologists

William Hutton's Map
of the Roman Wall

William D. Shannon

On 4 July 1801, 78-year-old William Hutton, a Birmingham-based book-seller, set out on foot for Carlisle, with the intention of becoming the first man since Roman times to walk the length of the Wall. In fact, he walked it both ways, Bowness to Wallsend and back, returning home on 7th August, after a walk of 601 miles (962 km) in 35 days. The following year he published an account of his journey as *The History of the Roman Wall*, which was influential in bridging the gap between the elite antiquarian visitors, who had hitherto been the only ones interested in the Wall, and the new, growing, 'popular' tourist market.

Hutton took with him a copy of Warburton's map of the Wall – and went on to include this reduced copy of that map in his publication. He would not have been aware, though, that Warburton had brazenly plagiarised a map which had earlier been published by Nathaniel Hill, showing the proposed Military Road between Newcastle and Carlisle, the need for which had been clearly demonstrated during the Jacobite Rising of 1745/6. In laying out this new road in 1749, the two surveyors, Dugal Campbell and Hugh Debeig, for reasons known only to themselves, decided to survey as well 'the Course of the ROMAN WALL'. The new road, now the B6318, is shown on Hutton's map as a dotted line.

Note that the map refers to the Wall as 'Severus's Wall'. Who was responsible for the stone wall had been a long-running debate, going all the way back to the Venerable Bede. For Hutton, Hadrian had merely been responsible for the bank-and-ditch which ran from sea to sea, long known as the Vallum – while the wall of stone had been built on the orders of the Emperor Severus, three-quarters of a century later.

A
Map of the
ROMAN WALL.

West Nickot

Amboglanna now Burdoswald

Thirlwall Castle

Aesica

Craig Hill

Wall

Vallum

Magna now Carvoran

Talentiers

Hayton

Severuss

Thorp

High Denton

Blenkinsop Cas:

Chapel

Petriana now Cambeck fort

High Wall Town

Hadrians

Denton Hall

Clowgill

Redpath

Laversdale

Comorinton

Crooks

Denton Mill

Fetherstone & Castle

Bea Cas:

Old Wall Town

Rowcliff

Beaumont Ch.

Haughton

Walby

Wall-head

Aballaba Rom.ⁿ Stat.ⁿ

thington

Brampton

Milton

Carnichel

Congavata now Stanwicks

Draw

Crosby

Newby

Edmon Castle

Dykes

Scale of Miles.

1 2 3 4 5 6 7

Monkshill

Hadrians Vall.

LUGAVALLIUM now CARLISLE

Aglionby

Lit. Corby

Hayton

Warwick

Memorial to John Collingwood Bruce

Richard Beleson

Hadrian ordered the building of the Wall to 'separate the Romans from the barbarians', but the Hadrian's Wall I know symbolises bringing people together. The first Hadrian's Wall Pilgrimage, which was organised by John Collingwood Bruce in 1849, whose memorial is in Newcastle Cathedral, included some twenty-four people, while the 14th Pilgrimage, which was organised by Chief Pilgrim David Breeze and his colleagues in 2019, included over two hundred people. We have all experienced our own personal Hadrian's Wall moments of solitude, perhaps collecting our thoughts with the wind and rain blasting in our faces while we were gazing at the mist and fog over Cuddy's Crag. However, most of our memories are of being with others - of sharing our exertions with fellow hikers, of imagining sharing a relaxing dip in the *caldarium* in the bathhouse at Chesters after an arduous day chasing after the *Brittunculi*, of sharing a story about the Wall with a fellow enthusiast, or of sharing a pint at Twice-Brewed. Similarly, if I may lift a phrase from Shakespeare's Julius Caesar, the 'most unkindest cut of all' while a great tragedy, is an incident that brings together people from all over the world who are of one spirit and with one shared memory - that very special moment when the Sycamore tree first came into view. The tree has been 'felled', but that memory will last forever.

Chesters Museum

William S. Hanson

I could have chosen several favourite sites on Hadrian's Wall, but I always experience a particular thrill when perusing the unique display of Roman antiquities drawn from the Clayton collection. They are housed in a purpose-built museum, which opened six years after John Clayton's death in 1890, adjacent to the site of the Roman fort at Chesters. Though owned by a board of trustees established in 1930, the collection is now cared for by English Heritage who have recently refurbished the museum, cleverly increasing the natural light while maintaining the original late 19th- to early 20th-century ambience of the displays. As well as housing a collection of international renown and importance, it has become almost a museum of museums with its simple display that focuses entirely on the Roman finds themselves, providing only minimal wider contextualisation or interpretation.

The collection contains over 23,000 Roman artefacts recovered from various sites in the central sector of Hadrian's Wall (between Brunton and Carvoran) that were owned by John Clayton. These were largely obtained from his own excavations, though it also includes material from work conducted within the estate after his death. Finds from Chesters figure very strongly, though there is also material from Carrawburgh, Housesteads, Haltwhistle, Carvoran and Vindolanda. The collection is made up of quantities of pottery and coins, including some 9000 from Coventina's Well, along with items of jewellery, tools, glass, military equipment and votive offerings. It is particularly well known for the large number of inscribed and sculpted stones, which range from altars via building inscriptions to statues. Thus, the museum offers a cornucopia of delight for anyone with an informed interest in Roman material culture. There are many hidden gems amongst the inscriptions, though a number of the more important ones are now usefully highlighted as the 'Curator's Choice'.

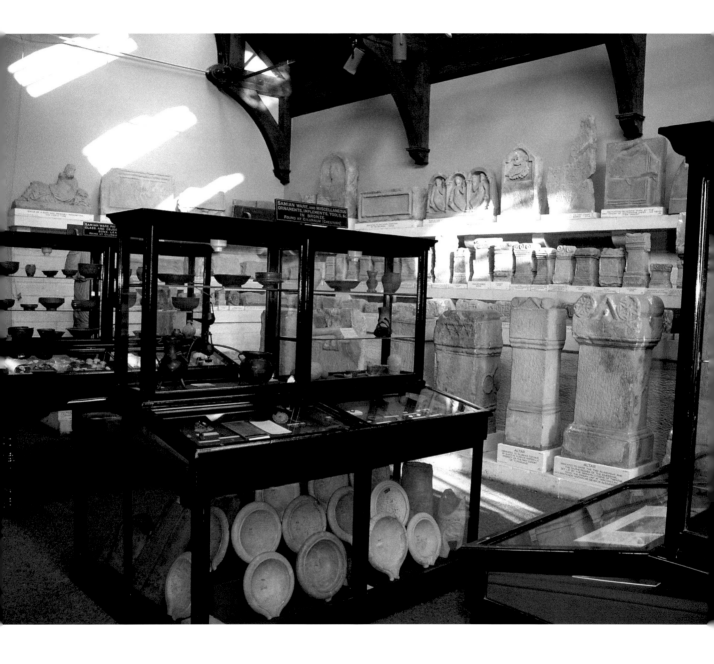

SAMIAN WARE, AND MISCELLANEOUS
ORNAMENTS, IMPLEMENTS, TOOLS, &c.
IN BRONZE
FOUND AT CILURNUM (CHESTERS)

SAMIAN WARE, PA
GLASS, AND OBJEC
BONE, LEA
FOUND AT CILURNUM

ALTAR

ALTAR

Elizabeth Hodgson on the Vallum

David J. Breeze

In 1894 Francis Haverfield commenced a ten-year campaign of excavation with the primary intention of understanding better the Vallum, the great earthwork behind Hadrian's Wall. Each year, Haverfield published a report in the *Transactions of the Cumberland and Westmorland Antiquarian and Archaeological Society*, the body which sponsored the work. He was helped from the beginning by Thomas Hesketh Hodgson and his wife Elizabeth Hodgson who prepared the drawings for these reports. In addition, Elizabeth Hodgson contributed some of her own 'Notes' on the excavations to the journal. Following the etiquette of the day, her publications were under the name, 'Mrs. Hodgson'.

In her first paper, Elizabeth Hodgson, after stating that she 'accompanied my husband to every trench which he was surveying and recording, in order that I might myself make notes …', she offers a disarming comment, 'I have no knowledge, except by mere hearsay, of the historical evidence that has been collected, and only wish to record the facts I have myself observed, and to give expression in the conclusions which I thought might logically be drawn from them. I began with no theory at all, and am not concerned to attack or defend any.' After this wonderful statement, Elizabeth Hodgson in four papers provided clear and unbiased descriptions of her observations and offered her own thoughts. The most important is, 'the builders of the so-called Vallum cared very much for the construction of the ditch and not much for anything else', a statement which remains unchallenged 127 years later.

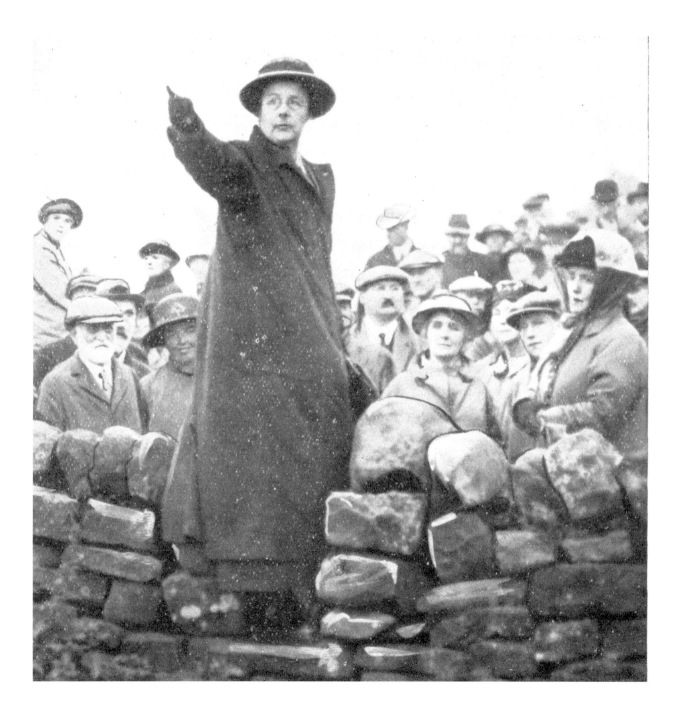

Chesters Bathhouse

Frances McIntosh

Chesters bathhouse is the best preserved military bathhouse in Roman Britain, a claim to fame of which John Clayton (1792-1890) would be extremely proud. Discovered by accident in 1884, the walls of the complex stand over six feet high in many places.

Chesters fort was one of five owned by John Clayton, along with around 20 miles (32 km) of Hadrian's Wall. It was at Chesters that his excavations were most extensive. I chose this illustration of the *apodyterium* from the bathhouse as for me it highlights the work by Clayton across the central sector of Hadrian's Wall. Clayton's role in saving large sections of Hadrian's Wall cannot be underestimated, particularly when considering iconic views. His work to consolidate and turf-top the Wall running west from Housesteads led to the creation of some of the most photographed sections of the Wall as it runs over the crags.

This illustration is by Robert Blair (1845-1923), long time secretary of the Society of Antiquaries of Newcastle, excavator of South Shields and talented illustrator. Blair made regular visits to Chesters mansion house, and to the excavations on the Roman site. He sketched both objects and monuments and his books are an invaluable record of the work of Clayton, often being key to confirming excavation dates and object provenance.

This view is also perfect for this book, as almost any group who visits the bathhouse gets a photo sat in the niches, definitely a modern view of the Wall!

Cilurnum
24.3.84

F. Gerald Simpson

Martha Lovell Stewart

Often the true significance of a figure from the past can only be appreciated with the lapse of time: F. Gerald Simpson (1882-1955) is just such a character. Apprenticed as an engineer to a firm of Tyneside shipbuilders in the first years of the 20th century, he set about acquiring practical skills, not least draftsmanship and photography, which would serve him well as a future excavator of the Roman Wall: *Hadrian's Wall* as it was more commonly known after he was able to prove that the frontier works had been constructed during that emperor's reign.

On weekend forays into the Northumberland countryside with his camera, the visible remains of the Wall caught Simpson's interest, and he joined the Society of Antiquaries of Newcastle in time to participate in the Wall Pilgrimage in June 1906, walking the whole route on foot. Having completed his training, he left a job in the shipyards to begin a new apprenticeship in archaeological excavation.

It had become clear to Simpson that fundamental questions about the date of the Wall (Hadrian or Severus?) and its original form (turf or stone?) remained to be answered. His potential was recognised by J. P. Gibson, a longstanding member of the Society who had excavated sites on Hadrian's Wall in the 1890s. Between 1907 and Gibson's death in 1912, the two collaborated in the archaeological investigation of the frontier with the trusted assistance of Thomas Hepple, Simpson's foreman. Simpson also sought to locate the position of turrets along the Wall. Here he is addressing the 1949 Pilgrimage of Hadrian's Wall at Chesters Bridge.

The 1914-18 War brought this phase of work to a halt. In the 1920s, Simpson helped to re-start excavations, and played a valuable role in mentoring the new generation of frontiers archaeologists including Ian Richmond and Eric Birley. Although dogged by ill health, he continued in partnership with Richmond, but deserves to be best remembered for his superb pre-WWI excavation work.

Ian Richmond at Birdoswald

John Wilkes

My favourite and memorable location is of the area south of Birdoswald fort towards the great scour of the river Irthing, from where on a clear day several of the Lake District hills are visible. The time is July 1956, when I first came to the north-east as a UCL student to attend the Corbridge 'Circus', days of memory when I first met Eric Birley, Ian Richmond, John Gillam, Norman McCord, Iain MacIvor, Wilf Dodds, John Mann (already an acquaintance at UCL) and many others, including the then 17-year old Tony Birley. The memory centres on the visit to the western sector, Gilsland, Harrow Scar, Birdoswald, Banks East turret and the Turf Wall at Appletree.

Eric's tale of the excavation history of Birdoswald recited at some length while standing on the East Gate, with stories of the Newcastle barber-surgeon Glasford Potter and the like was followed by an episode that made the area of the south of the fort memorable. Ian Richmond explained how the crucial evidence for the structural relationship between Wall, fort and Vallum was first demonstrated by excavation in that area he had conducted in the early thirties, and said he would locate the line of the Vallum for his student audience. He then set off into some bushes from which he emerges walking in an entirely different direction, then turned and walked towards us but suddenly turned away and headed towards the cliff edge. By this time his student audience could no longer conceal their amusement, even more so when he then turned again to disappear into the trees south-west of the fort. What we did not realise at the time was the complexity of remains in that area, and I can recall my amazement when much later I came to study his plan in the CWAAS report. I think that must have been the last occasion Richmond did this demonstration as he was soon due to move to the new Chair at Oxford.

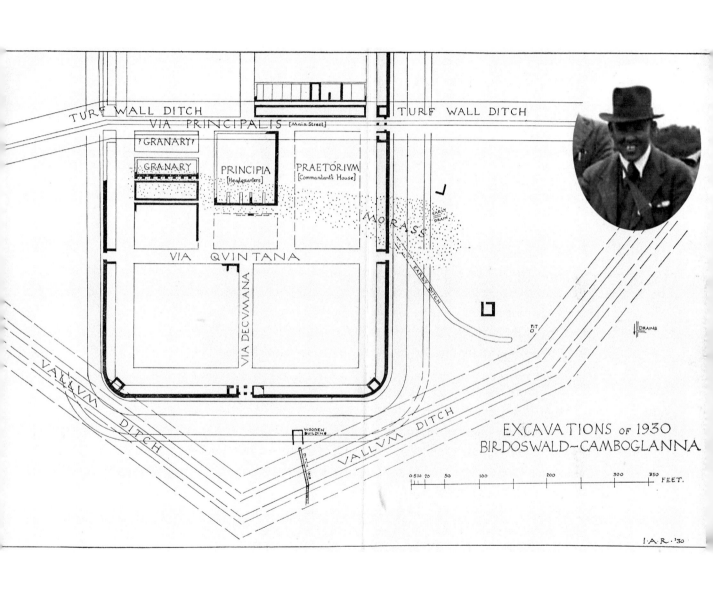

TURF WALL DITCH

VIA PRINCIPALIS [Main Street]

TURF WALL DITCH

?GRANARY?

GRANARY

PRINCIPIA
[Headquarters]

PRAETORIVM
[Commandant's House]

MORASS

EARLY DRAIN

VIA QVINTANA

VIA DECVMANA

EARLY DITCH

PIT

DRAINS

VALLVM DITCH

VALLVM DITCH

WOODEN BUILDING

EXCAVATIONS OF 1930
BIRDOSWALD–CAMBOGLANNA

0 5 10 20 50 100 200 300 350 FEET.

I·A·R·'30

The 1989 Pilgrimage at Milecastle 39 (Castle Nick)

Graeme Stobbs

When considering choosing my favourite place on Hadrian's Wall I realised the difficulty of such a task - there are so many outstanding and iconic parts to choose from. In my home I have numerous photographs, drawings, and watercolours of the Wall, ranging from a large original print of J.P. Gibson's photograph looking east from Cuddy's Crag, to a 'modern art' rendition of milecastle 39 executed in bold primary colours; and, as you would imagine, a small collection of views of the, now lost to us, sycamore tree - my personal favourite being a photograph of the tree silhouetted against the night-sky. However, I decided upon the top of Mons Fabricius (immediately west of Sycamore Gap) and the view westwards looking into the next gap which contains milecastle 39. Here I sat during the 1989 Pilgrimage of Hadrian's Wall (my first), and rather than join my fellow pilgrims exploring the milecastle I remained there, as I was rooted to that spot experiencing an overwhelming feeling of peace, calm, and of being 'home'. Some may suggest that it was a spiritual moment but as a nonreligious person perhaps another term applies. I've never experienced such a feeling since but passing this section I'm aways reminded of the time that I did – MY special place!

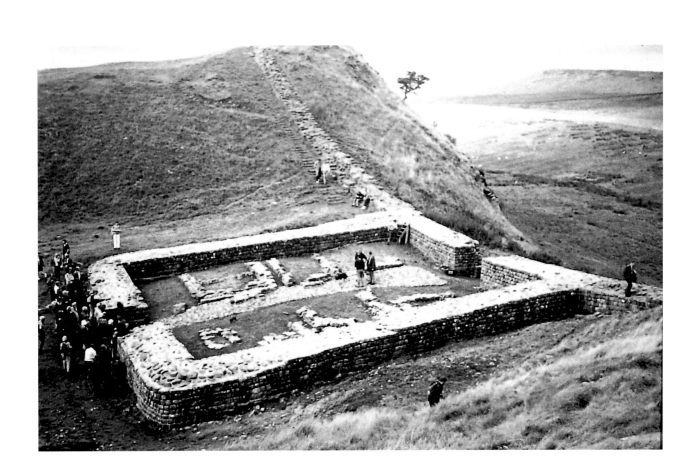

Great Chesters (*Aesica*)

Alan Whitworth

In 1985 I began the English Heritage funded project to record the visible Roman stonework of the fort which was in private ownership. Our small team of three was provided with various archaeological materials, a wooden hut together with associated equipment to allow us to carry out the required task and thus we proceeded to record by hand, assisted by rectified photography, the visible stretches of the fort structure. Normally it was a tranquil place to work with only the sound of birds, sheep and cattle which created a peaceful working environment. Occasionally the calmness was disturbed by the roar of low flying aircraft passing over the fort towards Spadeadam military range and the area is still host to this overhead activity and vision.

The views to all compass points on clear days was a visual delight and heart-warming, but when the mist or fog descended it was as if though we and the landscape was shrouded in our own small 'Mists of Time' world, where you could almost imagine the presence of former occupants of the fort. Work began in late autumn and continued into the winter when snow covered the ground and had to be cleared away to allow the recording to continue. Thick socks, hats, gloves and thermals were required to keep warm from the chilling wind which would sweep across the open site. The heater and cooker provided a much needed warmth during lunch breaks. Whenever I walk through the fort it reminds me that, starting from this place, Hadrian paid my mortgage, via English Heritage, for the next 25 years. *Mira memorias.*

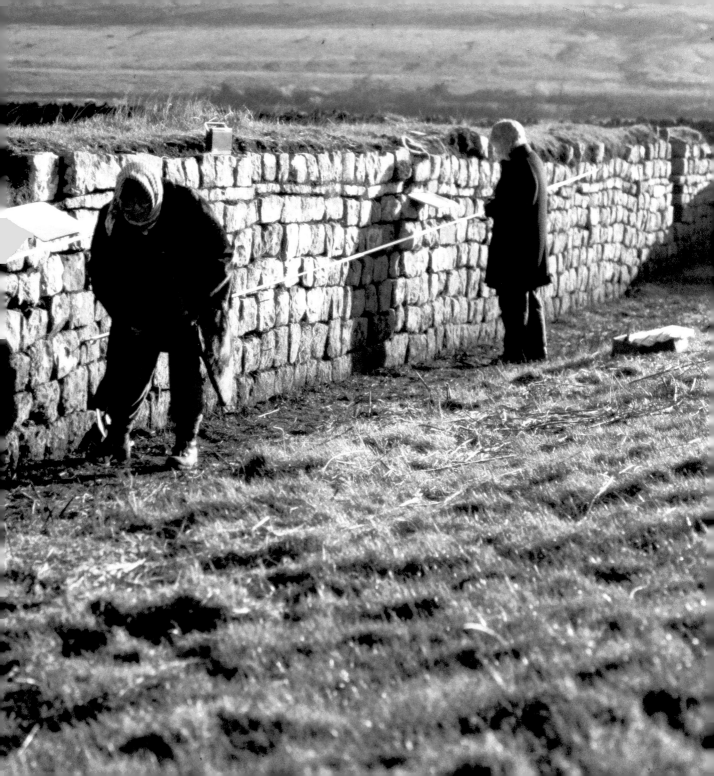

The Roman bridge, Corbridge

Margaret Snape

South of the Roman town of *Coria*, the Roman road known as Dere Street crossed the River Tyne on a bridge. Flooding on this turbulent river causes damage to its banks; erosion of the south bank exposed stones of the bridge abutment. Excavation by Tyne & Wear Archives & Museums in 2004 to record this also found remains of the huge ramp carrying the road across the bridge. A surprising discovery was several courses of a wall of massive stone blocks which protected the ramp. Because of the threat of further erosion, the stones were lifted from the riverside and the wall re-created on top of the riverbank. With the blocks arranged in their original position, the wall was on display in time for the 2009 Hadrian's Wall Pilgrimage, when I had the privilege of explaining the new monument to Pilgrims.

This fragment is a reminder of the network of Roman roads - and bridges - which criss-crossed Roman Britain. Before the end of the 7th century the bridge fell out of use. The first Anglo-Saxons arriving in the Tyne Valley found a landscape of great stone structures, ruinous but awe-inspiring, - 'the work of giants' - a stark reminder that all empires, however powerful, however long-lasting , will end in collapse and decay. Remarkably, they did not lose heart. East of ruined *Coria*, where a ford crossed the river, a new settlement sprang to life.

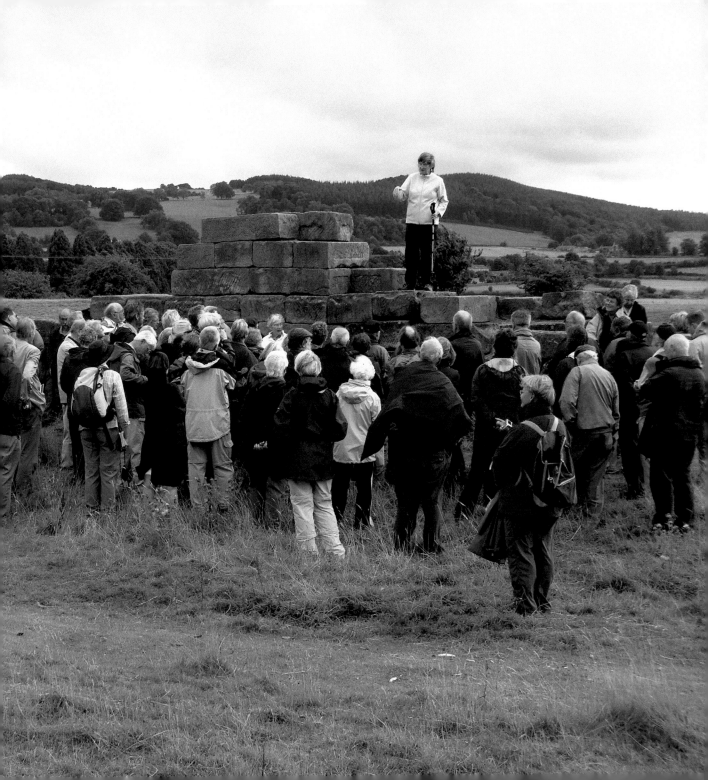

The Wall revealed at Newcastle's Mining Institute

Alan Rushworth

This overhead view shows the excavation trench dug in autumn 2017 in front of Neville Hall, better known as the Mining Institute and now called the Common Room. It was taken from one of the building's upstairs windows by Richard Carlton of the Archaeological Practice during a programme of archaeological evaluation prior to the building's renovation. Two stretches of the south face of Hadrian's Wall are visible at the right- and left-hand edges of the view, both consisting of an offset footing slab and a single surviving course above. That on the right represents the same length of Wall that was famously exposed by F.G. Simpson in 1952.

Surrounding features illuminate something of the structure's post-Roman fate, emphasising that, however significant it may have been, Hadrian's Wall represents only one episode in the long and complex evolution of Newcastle. Particularly notable is the deep ditch of a late medieval culvert, partially revetted in stone on the left (west) side, which slices obliquely through course of the Wall. The channel in the bottom of the ditch was originally covered by a flagstone which can be seen higher up in the trench. To the right, the culvert also cuts through the deposits burnt a dark red colour, where an oven stood earlier in the Middle Ages. Two fragmentary walls, characterised by very white mortar and an internal brick skin, can also be seen running north-south over the top of the Wall. These mark the east range of the Jacobean house, later variously (and confusingly) labelled Westmorland Place or Westmorland House. It was the neighbouring Lit and Phil plot that was associated with the Neville earls of Westmorland.

Hence, this photograph exemplifies the way that developer-funded archaeology has driven forward discoveries along the Wall in recent decades, at least in the more densely occupied districts of Tyne and Wear and Carlisle.

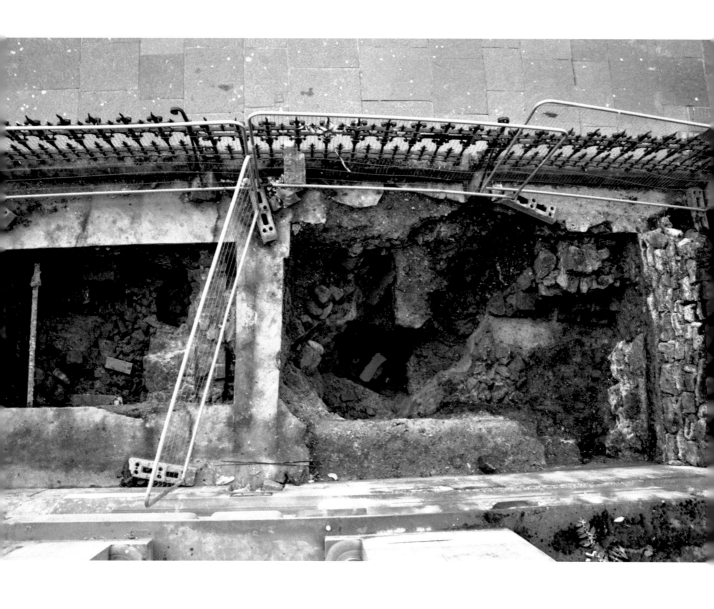

Heddon-on-the-Wall

Matthew S. Hobson

Four years ago, I left a career in academia researching the North African provinces of the Roman Empire for a job in commercial archaeology, moving our family to the north of England. My new employer Wardell Armstrong LLP has an office in Carlisle, and it was intended that from there I should produce archaeological publications. Direct involvement with the archaeology of Hadrian's Wall began immediately. Upon my arrival, in March 2020, the firm had just completed a watching brief for a new housing development at Heddon-on-the-Wall. The very base of the Wall was unexpectedly found to have survived in a location where it had been thought to have been completely destroyed. Research for the client report quickly demonstrated that the discovery had important implications for the location of milecastle 12. Shortly afterwards, David Breeze got in touch with me to discuss the significance of the find in relation to the work he was conducting on the sequence of the construction of Hadrian's Wall. Once I had shared the details, he informed me that the results were also of considerable interest to him, as they confirmed that stones categorised as 'very large' and 'massive' had been used in the original construction of this section of the Wall.

Although I had some previous knowledge of the archaeology of the frontier zone from family holidays, and study trips with my tutor and supervisor David Mattingly, this work at Heddon-on-the-Wall proved to be the real beginning of my education in matters relating to Hadrian's Wall. In the years that followed, I have had the pleasure of working with Ian Haynes and Tony Wilmott at Birdoswald and writing about Wardell Armstrong's geophysical survey at the fort at Carrawburgh and our excavations of an early 2nd century cremation cemetery beneath Cumbria House in Carlisle. Heddon-on-the-Wall, though, will always have a special place in my memory, as the first project I wrote about - a good demonstration of how unexpected views of the Wall can be experienced in a commercial context.

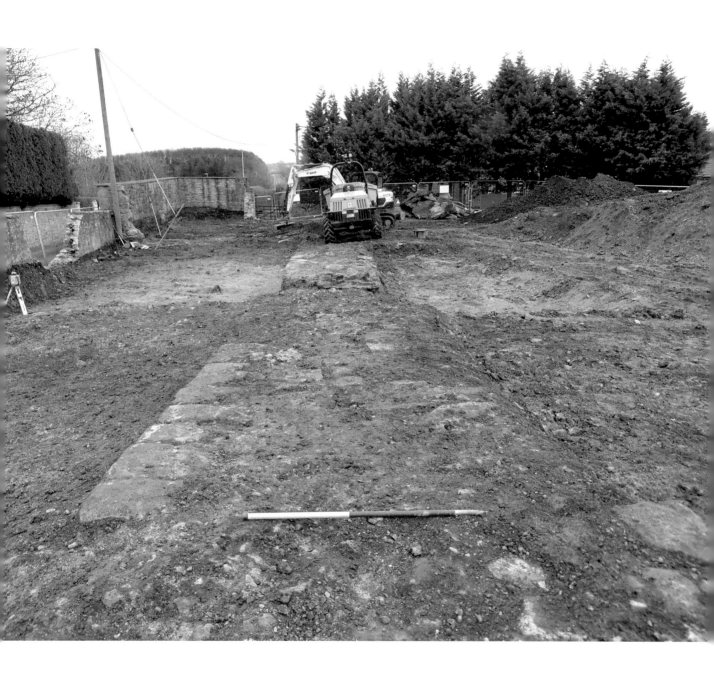

Milecastle 46 (Carvoran/*Magna*)

Rachel Frame

Sitting on the western edge of the Whin Sill, high above the Tipalt Burn, milecastle 46 has a commanding view westward towards Birdoswald. On a clear day, landmarks as far away as Burnswark hillfort and Criffel on the Solway Firth can be seen outlined on the horizon. Like so many spots along Hadrian's Wall, the setting is both picturesque and strategic; and standing on top of the spoil heap looking over the excavations of milecastle 46, you get a strong sense of the view that a Roman soldier would have had nearly 2000 years ago.

Only a small, mounded earthwork remained to mark the location of this particular milecastle until our excavations brought it to light once more. Whilst it may not be the most visually impressive section of the frontier, there has nonetheless been much to learn about the history and importance of this small outpost, and I look forward to uncovering more of its secrets.

When I first visited Hadrian's Wall as a teenager, determined to become an archaeologist, I could only dream of one day excavating this iconic landmark. It is a joy to be part of writing the next chapter in the history and research of the Wall, continuing the legacy of generations of archaeologists, and hopefully inspiring the next cohort to follow in our footsteps.

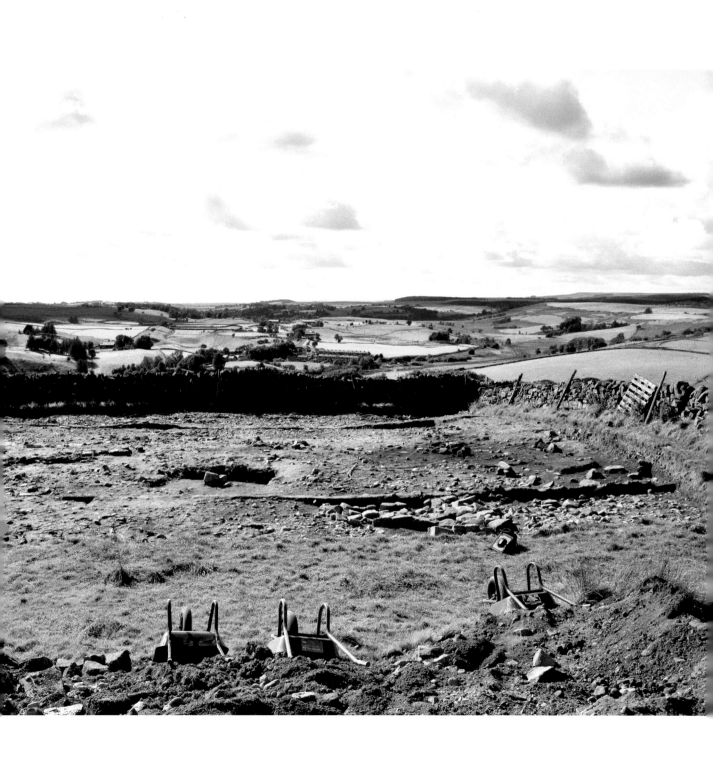

The Visualisation of the Wall and *Pons Aelius*

David Heslop and Iwan Peverett

Our view is part of an interpretation piece showing how *Pons Aelius*, the Roman fort at Newcastle, might have appeared as seen from Central Station, and is based as accurately as possible on the archaeological evidence of over 50 excavations, records of finds and antiquarian observations. Hadrian's Wall can be seen to the north of the fort, with an extra mural settlement or *vicus* to the south and west. The panoramic view was created by New Visions Heritage Limited for Vertigo Creative and Newcastle City Council. In creating the 3D digital model which formed the basis of the photo-realistic visualisation, Iwan, the digital artist, was inspired by his childhood memories of the excitement and fear of being charged by the Ermine Street Guard at the Lunt fort near Coventry. Just outside the west gate of the fort may have been a parade ground where we can imagine the Roman auxiliary troops (in 213 a cohort of *Cugerni* from Lower Germany) practicing their manoeuvres, reigniting those childhood memories.

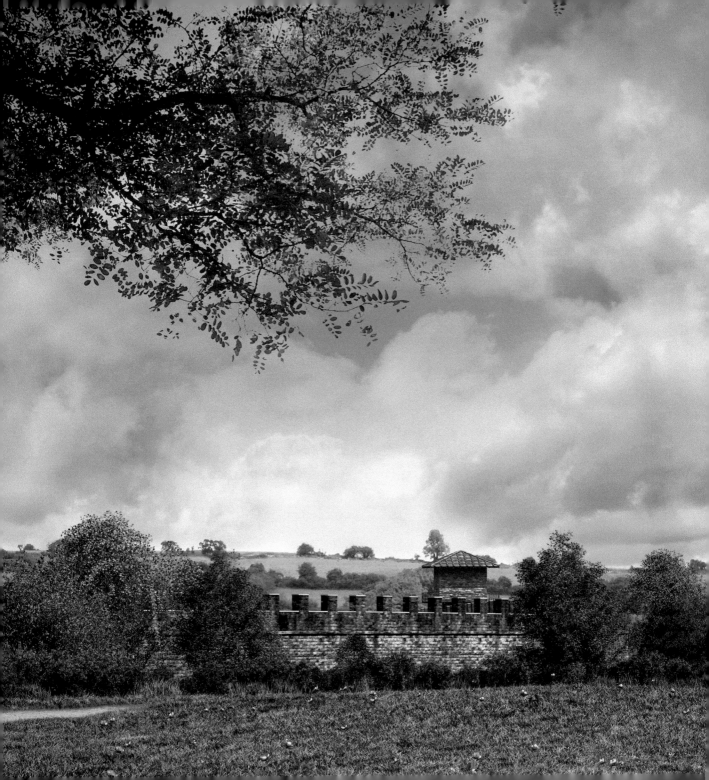

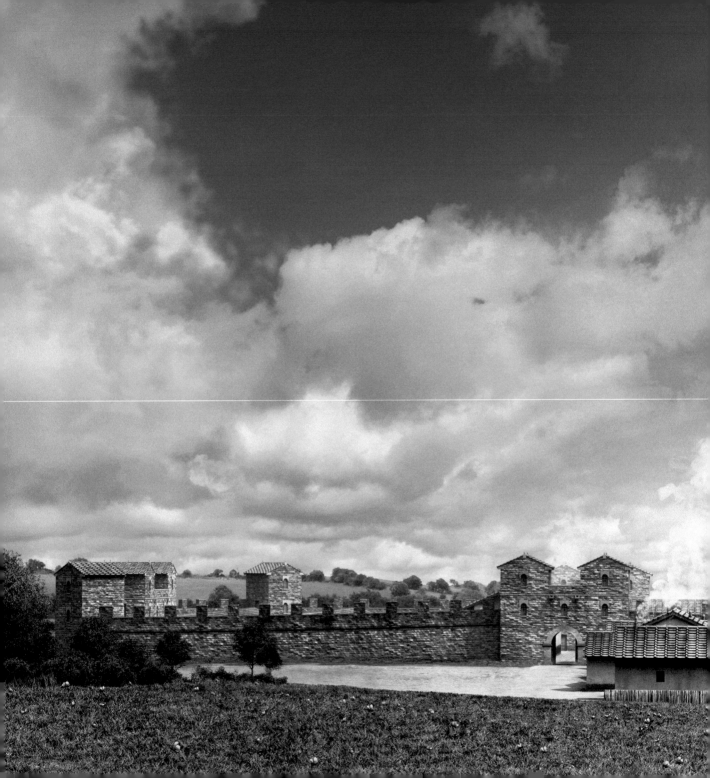

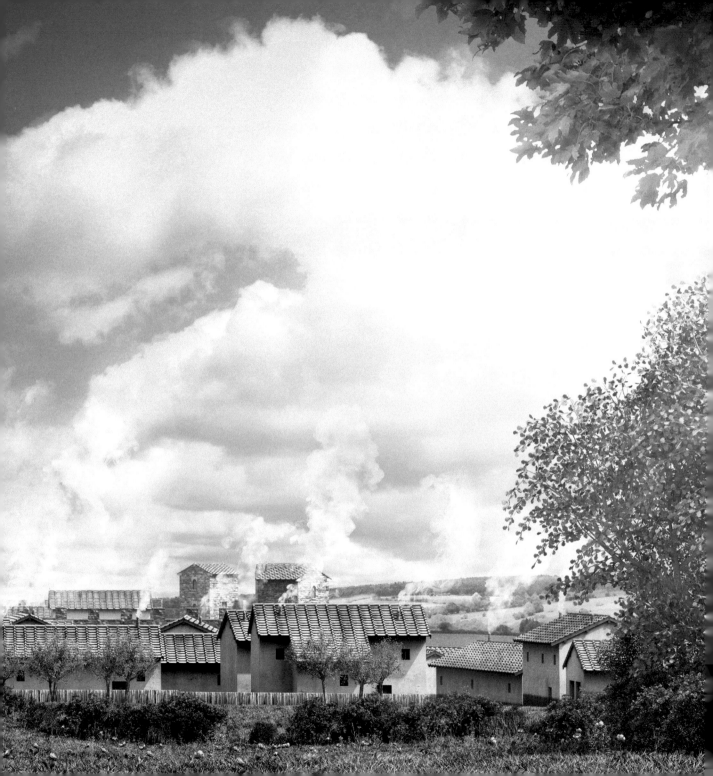

The Excavation and Consolidation of the Wall at Walltown in 1959

Barbara Birley

This is one of the striking images from the Charlie Anderson Photographic Archive. Taken in 1959 at Walltown, this photograph shows workmen preserving and consolidating the recently excavated monument, an ongoing process in the management of the World Heritage Site even today.

Charlie Anderson was employed by the Ministry of Works for almost 40 years as a stone mason and then foreman, leading teams which cared for and maintained the Wall. He worked on almost every section of the Wall and took a series of meticulous images of the operations being carried out. This archive is a unique window into the past. It helps us to understand the modern history of the Wall and memorialises the ongoing efforts to preserve it for future generations.

In 1996, Walltown Crags was one of my first encounters with Hadrian's Wall. This is where my fascination with the depth of history and the impact on the landscape of the Wall began. Little did I know, when looking out at the stunning view that day, that I would join a dynamic community that fosters a passion to protect, inspire and engage all who visit the Wall with our shared Roman past.

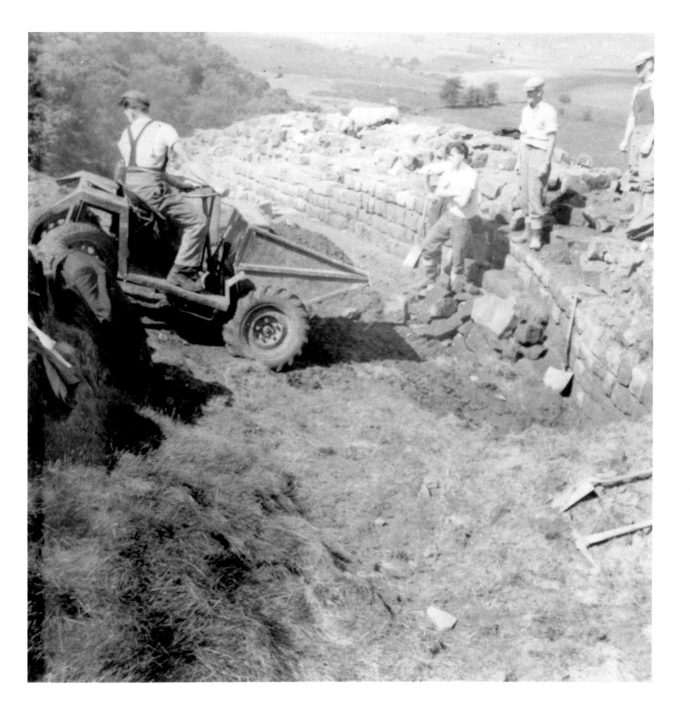

Taking Roots on the Wall

Tanja Romankiewicz

It's 25 years since I first came to Hadrian's Wall, in search of those iconic views I knew from books. If someone had told me then that I would now be "taking roots" here, I would not have believed them. But I have taken roots, literally… from the turf ramparts of the early forts excavated at Vindolanda. And I didn't just take roots. As part of a research team from the University of Edinburgh, we took soil samples from turf blocks across the whole "stripy" section. Our illustration shows a rectified photograph of three building periods. I meticulously outlined every turf block to show the different block shapes, cut by different military units. These blocks look even more beautiful in thin section under the microscope (inset), showing three turf blocks with their yellow subsoil, brown topsoil and black lines of decayed grass. This demonstrates that the blocks had been laid upside down in this rampart.

And although we cannot see this rampart section anymore because it was backfilled, the samples give us a view into Roman construction. The soldiers selected well-rooted turfs for better tensile strength, repeatedly exploited the same cutting locations, and every unit cut their own specific block shape, seemingly mirroring their ancestors' building practices. Some units were originally raised not too far from my original homelands. So, here I am today, reconnecting with possible ancestors by analysing their 1,900-year-old walls.

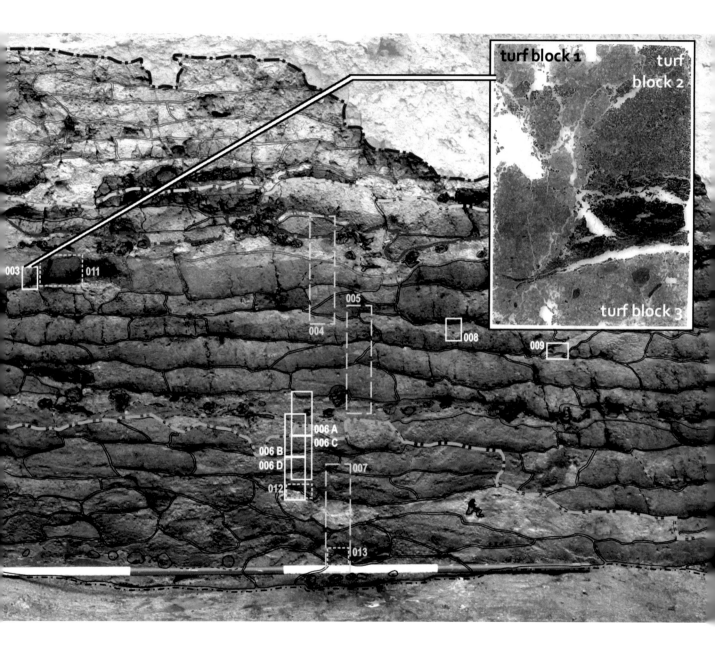

turf block 1

turf
block 2

turf block 3

003 011

004

005

008

009

006 A
006 C

006 B

006 D

012 007

013

Carlisle Cricket Club

Frank Giecco

Having excavated on the frontier zone for almost 30 years, I have been lucky enough to work on many significant sites throughout the area, and selecting a single site that means more to me than any other was a considerable challenge. I have chosen my current project at Carlisle Cricket Club, located beside the picturesque River Eden, close to Hadrian's Wall and the fort at Stanwix. The site is currently thought to be a bathhouse/villa complex and has played a huge role in my professional career and the lives of hundreds of volunteers over the last five years.

The complex sequence of archaeological remains that we have unearthed never fails to surprise me, reminding me why I became an archaeologist and continue to be one. In an area where there are no extant remains of Hadrian's Wall, the structural remains of the bathhouse and the spectacular finds recovered have allowed the local population to connect with Carlisle's past as the northern most city of the Roman Empire. Nothing has engaged the local population more than the two monumental sandstone heads recovered from the site in 2023. The heads, together with other significant finds were displayed locally and were seen by over 10,000 people, each visitor has taken something from viewing them in person and many have their own interpretation of what they represent. Although the monumental scale of the Severan bathhouse complex and wealth of finds dating to about 210 is astounding, the site is special to me, and to countless others, as it has brought so many people together. It has allowed people to have hands on archaeological experience, gain skills and forge new friendships whilst igniting pride and enjoyment of Carlisle's Roman heritage.

Last Words

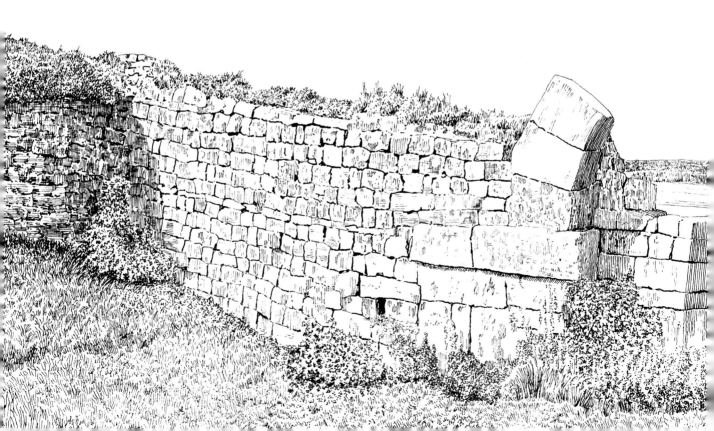

Bowness-on-Solway Hadrian's Wall Path Passport Stamping Station

Tatiana Ivleva

In 2010, I walked with my future mother-in-law (a great bonding experience!) Hadrian's Wall Path from west to east. The distance of our journey was not measured in miles or days passed by unnoticed, but rather in the sections between the seven passport stamping stations along the Path. At each of these stations a special Path passport can be stamped that allows walkers to track their progress. At the end of the Trail, walkers can receive a completion badge and certificate by showing the passport with stamps. Walking the Trail is no easy task. I remember the joy and sense of accomplishment we felt each time we reached a stamping station after a long stretch of walking, adding another stamp to our collection. The most memorable of all the stamping stations is the one at the Banks Promenade near Bowness-on-Solway. While some stations are located inside structures such as inns, museums, or event centres with swimming pools, this one is in a wooden hut surrounded by trees on one side and the flat expanse of Solway Firth on the other. This serene location adds to the unique experience. Memory might play tricks with me, as I write this eulogy in 2024, but I can't shake the otherworldly feeling I had in that hut back in 2010, as if I were in the middle of a desolate landscape with no human habitation for miles. Now, I realize that this otherworldly feeling the simple hut evoked reminds me of the TARDIS, Dr. Who's centuries-old time travel machine that can go anywhere in time and the universe. A passport stamping time-travel station where one gets their travel document stamped while crossing to and from the Roman world.

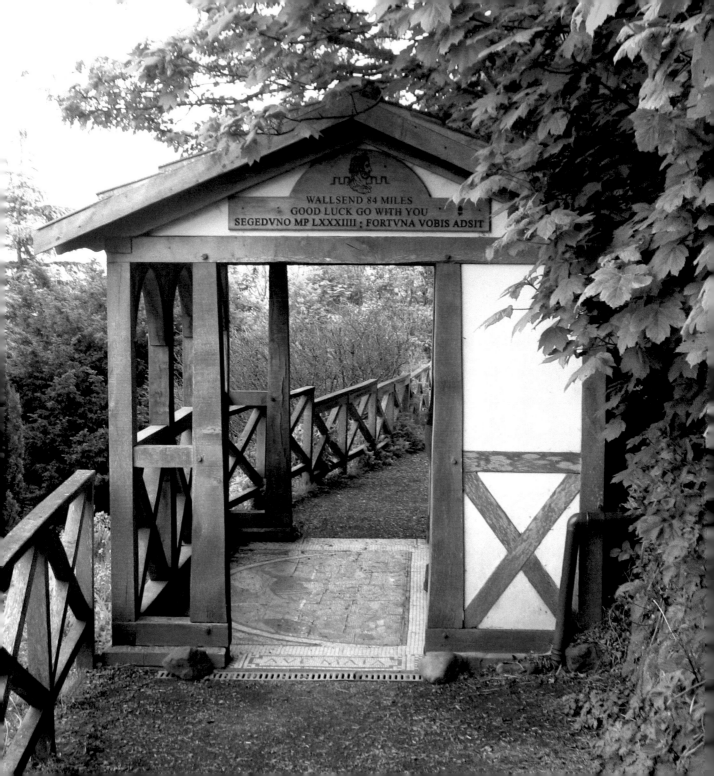

A Living Wall

*Emily Hanscam and
Cornelius Holtorf*

For us, Hadrian's Wall is a symbol of the Roman past, a reminder of how the past lives on, and most importantly, of how we must embrace change and transformation. The recent felling of the Sycamore Gap tree provided a poignant example of why this perspective is important. Just as the Wall is a living monument, so is the tree. The cuttings of the fallen tree are already showing new growth, and the felling of the tree may inspire more to visit the site of its stump and remaining roots; inspiring thoughts of continuous growth, regeneration, and transformation over time. This has larger implications and can inspire us all to appreciate not only cultural heritage and the historic environment but also how global peace and even the ideal of a united Europe keep going through processes of transformation. Instead of sentimentalizing what is gone we should embrace the changes and look for emerging opportunities of development.

While for many, the Wall remains an archetypal ancient border, for us it is a place that brings people together. When I (Emily) visited the Wall at Housesteads with multiple groups of students and guests of the Durham archaeology department, I most enjoyed exploring westwards through the trees, viewing the new life alongside the old and discussing how we ourselves were experiencing the landscape.

I (Cornelius) found images which confirm my visit of a section of Hadrian's Wall in 2009. This was on a memorable trip together with my children (who were 3 and 7 at the time) and an archaeologist friend and her young son. There was a sign proclaiming that "In the interest of conserving the archaeology would visitors please keep of the wall". Why did it not say that "This is a site that has been changing many times before and will continue to do so. If you climb on the wall you contribute to the archaeology of tourism"?

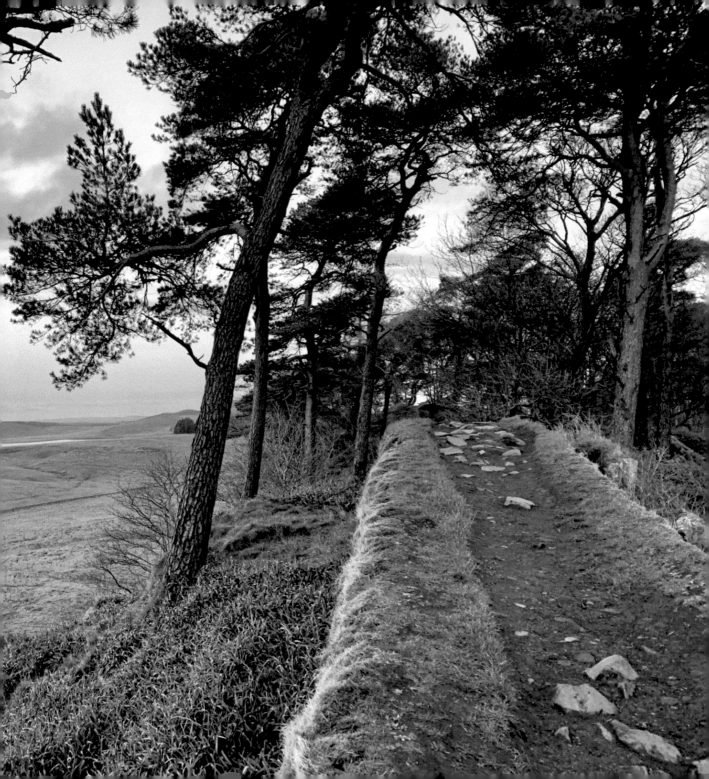

Boots for Walking

Carol van Driel-Murray

I can't hope to emulate the evocative photos of other contributors, and, anyway, how does one choose? Every spot along the Wall is extraordinary, each visit brings something new, even if it's only a change in the sunlight and the racing clouds.

So I've opted for Erik Graafstal's boots following a week guiding us on the Hadrian's Wall Pilgrimage in 2019. It is a tribute to the thousands of feet that have trudged the Wall though the ages and the shoes they left behind. The roads busy with travellers, soldiers, administrators, merchants, men, women and children in the high point under the Roman Empire, dwindling to almost nothing in the centuries thereafter, except for the odd sheep-rustler or fugitive. Then the first intrepid explorers, keen walkers all, with sturdy boots that, with their hobnails and multiple soles, didn't differ so much from those of the Roman soldier centuries before. And today, the endless line of bobbing, coloured hoods and capes on the horizon, like so many *cuculli* marking the line of the Wall as surely as a Roman guardsman.

> Marching, clambering, exploring, stumbling, limping,
> always
> following
> in the footsteps
> of those who went before

A Piper's Lament

Kim Bibby-Wilson

The inspiring landscape of Hadrian's Wall has always evoked a creative response from musicians: a quick internet search will find a number of tunes and songs celebrating the Wall and the Sycamore Gap tree in its glory or lamenting its loss.

Well suited to both energetic rippling melodies and lyrical airs or laments, the soft tones of the bellows-blown Northumbrian small pipes have often been heard at events connected with Hadrian's Wall. In the days of the Society of Antiquaries of Newcastle's gloriously-named Ancient Melodies Committee and the 1882 publication of the bible of local music and song *Northumbrian Minstrelsy*, the pipes were played at dinners or receptions during the Hadrian's Wall Pilgrimages of 1886 and 1906 by Richard Mowat and James Hall (Piper to the Duke of Northumberland) respectively; much more recently, since the establishment of the Morpeth Chantry Bagpipe Museum, I have been honoured to play the small pipes at the last four Pilgrimages, and also introduced our local instrument to the international 2009 Congress of Roman Frontier Studies in Newcastle. Perhaps the most memorable occasion was being invited to play at a hand-fasting ceremony for an Australian couple at Steel Rigg. Some passing German tourists seemed to assume this was a normal occurrence in such wild parts.

The first pipes tune here, *The Sycamore*, is followed by *Mind The Gap* – not a facetious title, but a gentle pun on both the Northumbrian expression "mind" meaning "remember, be mindful of" and the Standard English usage for "object to", reflecting the outrage felt when the tree was felled. This second tune starts in a cheerful major key with tree and landscape in harmony, but is cut off with a slow descent into the more poignant minor key of the lament.

http://doi.org/10.32028/9781803277349-MUSIC

The Sycamore

Mind The Gap

Epilogue

The initiative to create this book sprang from a tragedy and turned into a joyous occasion. At the end of four months of intense activity, what have I, as the co-ordinator, learnt? The most importance is the eagerness of my friends and colleagues to participate in the project. This was typified by Richard Beleson submitting his contribution by return. But more than that was the image he chose, the memorial to John Collingwood Bruce in St Nicholas' Cathedral in Newcastle. Bruce was the great interpreter of Hadrian's Wall through most of the second half of the 19th century. His legacy remains huge: the Pilgrimage of Hadrian's Wall, probably the oldest continuing archaeological tour in the world, first held in 1849; and the *Handbook to the Roman Wall*, now in its fourteenth edition since 1863 and therefore the oldest archaeological guide-book continuously in print (contributions by Hazenberg, Protić, Stewart, Stobbs, Snape, van Driel-Murray and Bibby-Wilson). The Man, the Pilgrimage, the Book: all bear witness to the transmission of knowledge over the decades.

The second lesson was not so much what views colleagues chose, but what they didn't choose. No Planetrees, saved from destruction by the pleas of William

Planetrees being examined by Erik Graafstal

Benwell Vallum Crossing

Hutton in 1801 (Shannon), being examined here by Erik Graafstal, a contributor to this book. No Benwell Vallum Crossing, the uniquely visible example of a unique structure on any Roman frontier. These omissions were the result of the choices of individual contributors, and several struggled hard with their choice, me included. The first excavation I attended was at Corbridge next to the Wall in 1963 (no one chose Corbridge whose history is so linked to that of the Wall), I directed my first excavation within the fort at Carrawburgh from 1967 to 1969, and I participated in the excavation of turret 33b (Coesike) under the direction of Roger Miket and Valerie Maxfield, but in the end chose Elizabeth Hodgson for her intellectual rigor.

The third lesson relates to the links over the generations. In 1963, the excavation at Corbridge was led by Eric Birley and John Gillam, with John Wilkes one of the site supervisors. Eric worked with Ian Richmond and F.G. Simpson in the 1920s and 1930s (Stewart), and Simpson before that with John Pattison Gibson, who undertook his first excavation on Hadrian's Wall in 1892, the very year Bruce died. The site was turret 44b (Mucklebank), chosen by Beth Greene as her contribution. These archaeologically genealogical links are fun, but also important, for they testify to the transmission of traditions and knowledge, in particular how and why things happened in the past (note the importance of Harry van Enckevort's pint, taken

on the Pilgrimage when so many Wall buffs are gathered together). The anecdotes, such as the event described by John Wilkes, help us understand the figures who helped create today's archaeological world.

And so do their records. John did not just choose Richmond's plan at Birdoswald because it was a physical link with the excavator and his own visit to the site as a post-graduate student, but also because Richmond's reports were of *his* time and it is important that we understand the interpretations that shaped his view of Hadrian's Wall and therefore ours.

I, and other contributors, have heard it said that there is no more to learn about Hadrian's Wall. How wrong they are. Many contributions reflect new discoveries, including that by Tanja Romankiewicz, writing on behalf of her colleagues and herself on how much we can learn from studying turf ramparts, not least about the landscape in the years when the Wall was built and occupied. Fifty years ago, who would have predicted an enormous Roman building in Carlisle and its contents (Giecco), or the Vindolanda (and now Carlisle) writing tablets (Andrew Birley)? The gaps in our knowledge of Hadrian's Wall remain enormous; great discoveries lie ahead, challenges too. In another fifty years – sixty in my case counting from my first excavation on Hadrian's Wall, seventy in the case of John Wilkes – our successors will be able to look back and judge how much progress has been made, in part from consulting this book. They will be grateful to all contributors who took time out to write about our special Roman frontier, made all the more poignant by the personal nature of so many contributions.

Eighty and more archaeologists, cultural resource managers, site managers, curators, university lecturers and private individuals from both Britain and abroad (itself a phenomenon which would not have happened twenty years ago) have offered their own personal glimpse into Hadrian's Wall in *our* time. Through these contributions, they have reminded us how and why we study one of the greatest surviving monuments of one of the world's greatest states, the Roman Empire.

David J. Breeze
Edinburgh
4 February 2024

Further Reading

There is an extensive bibliography of Hadrian's Wall. In 1851 John Collingwood Bruce published his first book on Hadrian's Wall, *The Roman Wall*. The direct successor of this book is the 14th edition of the *Handbook to the Roman Wall*, edited by David Breeze, published by the Society of Antiquaries of Newcastle, and probably the oldest archaeological guide-book still in print anywhere in the world (available from Archaeopress).

The various bodies which care for Hadrian's Wall produce their own books. English Heritage, which has many parts of the frontier in its care, publish a souvenir guide and individual site guides. In 1999 the National Trust published a book about their estate in the Housesteads area, *Hadrian's Wall, an historic landscape* by Robert Woodside and James Crow.

There are several other bodies involved in the care and management of sections of Hadrian's Wall, each with their own range of publications, The Vindolanda Trust runs Vindolanda and the Roman Army Museum at Carvoran; Tyne and Wear Museums manage South Shields and Wallsend/*Segedunum*; Northumberland County Council owns Rudchester fort; the Senhouse Museum Trust at Maryport runs the Senhouse Roman Museum. Information on these sites and bodies is easily available on the internet and, of course, at the sites themselves.

Hadrian's Wall is part of the Frontiers of the Roman Empire World Heritage Site. Archaeopress publish a series of 20 multi-language books on the various elements of this World Heritage Site including one on Hadrian's Wall in English, French and German and on the Hinterland of Hadrian's Wall in English and French. For more detailed publications see:

David J. Breeze, *Hadrian's Wall: A Study in Archaeological Exploration and interpretation*, Archaeopress, Oxford 2019
Peter Hill, *The Construction of Hadrian's Wall*, Tempus, Stroud 2006
Richard Hingley, *Hadrian's Wall. A Life*, OUP, Oxford, 2012
Nick Hodgson, *Hadrian's Wall: Archaeology and history at the limits of Rome's empire*, The Crowood Press, Marlborough 2017
John Poulter, *The Planning of Roman Roads and Walls in North Britain*, Stroud 2010
Matthew Symonds, *Hadrian's Wall: Creating Divisions*, Bloomsbury, London 2021

Most reports on excavations on Hadrian's Wall, as well as discussion papers, are published in *Archaeologia Aeliana*, the journal of the Society of Antiquaries of Newcastle upon Tyne, and the *Transactions of the Cumberland and Westmorland Antiquarian and Archaeological Society*: further information on their websites.

Acknowledgements and Credits

I am most grateful to Lesley Macinnes for her careful copy editing of the text, to Erik Graafstal for his advice, and to Roger Miket for his helpful discussion of the contents of this book, not least for suggesting the composition of a lament for the tree. David Heslop would like to thank Nigel Mills for help with copyright issues. Kim Bibby-Wilson would like to thank Bennett Hogg, Senior Lecturer in Music, Newcastle University, for setting the musical score.

The editor and publisher is grateful to the following for the provision of illustrations, copyright residing with the body or person cited: Rebecca Vincent (xii); David J. Breeze (4, 109, 167); Northumberland Archives (171), Woodhorn (5, 13); Tyne & Wear Archives & Museums (8; 57, 59; 133); Laing Art Gallery, Newcastle upon Tyne, Tyne & Wear Archives & Museums (9, 16, 19 top, 69, 101, 139); Society of Antiquaries of Newcastle (10, right); Tullie House Museum and Art Gallery (11, bottom; 53; 137); Historic England (12, 39, 67); Judith Yarrow (19 bottom); Alexander Friedrich (21); WikimediaCommons, Steven Fruitsmaak (27); Tim Gates (37); Peter Savin (77); Sonya Galloway (41); Google Earth (43); Richard Beleson (49, 165); Great North Museum: Hancock. From the collection of the Society of Antiquaries of Newcastle upon Tyne (51); Sarah Deane Photographic (97); Jane Laskey (117); Jon Coulston (123); Trustees of the Clayton Collection/English Heritage (125, 143); Historic England/English Heritage (127); Vindolanda Trust (129, 131, 185); Solwayconnections Guided Tours (155); the Earthen Empire team (Ben Russell, Chris Beckett, Riley Snyder, Benedicta Yi Xin Lin, Rose Ferraby, Tom Gardner and Tanja Romankiewicz) (193).

Other photographs are the copyright of the author of the contribution.
The line drawings by Mark Richards are available from: fellranger1@gmail.com
Anchored, monotype by Rebecca Vincent is available from www.rebecca-vincent.co.uk

List of Contributors

Marta Alberti, The Vindolanda Trust

Lindsay Allason-Jones, Past President of the Society of Antiquaries of Newcastle

Amy Baker, post-graduate student, Newcastle University

Richard Beleson, San Francisco Ancient Numismatic Society

Kim Bibby-Wilson Chair, Morpeth Northumbrian Gathering

Andrew Birley, Director of Excavations, The Vindolanda Trust

Barbara Birley, Curator, The Vindolanda Trust

Emanuela Borgia, Professor of Classical Archaeology, Sapienza University, Rome

David J. Breeze, Past President of the Society of Antiquaries of Newcastle and the Cumberland and Westmorland Antiquarian and Archaeological Society

Richard Brickstock, independent researcher and numismatist

Maureen Carroll, Professor of Roman Archaeology, York University

Abigail Cheverst, community/heritage freelancer

Mike Collins, Team Leader for Development Advice, North East and Yorkshire, Historic England

Rob Collins, senior lecturer (material culture of the northern frontier), Newcastle University

Jon Coulston, lecturer in Ancient History and Archaeology, St Andrews University

Eleri Cousins, lecturer in Roman history, Lancaster University

Alex Croom, Curator, Tyne & Wear Archives & Museums

Jim Crow, Professor Emeritus, Edinburgh University

Eckhard Deschler-Erb, Professor of the Archaeology of the Roman Provinces, University of Cologne

Christof Flügel. Head Curator, Bavarian Museums Service

Rachel Frame, senior archaeologist, Magna Project, The Vindolanda Trust

Jane Gibson, Chair, Hadrian's Wall Partnership Board

Frank Giecco, Technical Director, Wardell Armstrong Archaeology

Erik Graafstal, Municipal archaeologist, Utrecht, The Netherlands

Elizabeth M. Greene, Associate Professor in Roman archaeology, University of Western Ontario, Canada

Bill Griffiths, Head of Programmes and Collections, Tyne & Wear Archives & Museums

Emily Hanscam, researcher, UNESCO Chair on Heritage Futures, Linnaeus University

William S. Hanson, Professor Emeritus of Roman Archaeology, University of Glasgow

Ian Haynes, Professor of Archaeology, Newcastle University, and Chair of Archaeology, British School in Rome

Tom Hazenberg, Hazenberg Archeologie, The Netherlands

Dave Heslop, New Visions Heritage Ltd, President of the Society of Antiquaries of Newcastle

Richard Hingley, Professor Emeritus, Durham University

Matthew Hobson, Associate Director, Wardell Armstrong Archaeology, Honorary Visiting Fellow, University of Leicester

Nick Hodgson, Honorary Research Fellow Durham University, past president of the Society of Antiquaries of Newcastle

Cornelius Holtorf, Professor, UNESCO Chair on Heritage Futures, Linnaeus University

Tatiana Ivleva, Visiting Research Fellow, Newcastle University

Ian Jackson, formerly Operations Director of the British Geological Survey

Rebecca H. Jones, former Head of Archaeology and World Heritage, Historic Environment Scotland; co-chair of the Congress of Roman Frontier Studies

Paul J. Kitching, post-graduate student, Durham University

Jane Laskey, manager, Senhouse Roman Museum, Maryport

Al McCluskey, post-graduate student, Newcastle University

David McGlade, former head of the Hadrian's Wall National Trail

Lesley Macinnes, independent researcher, former Head of World Heritage, Historic Scotland

Frances McIntosh, curator of English Heritage Museums on Hadrian's Wall

Alex Meyer, Associate Professor, University of Western Ontario, Canada

Roger Miket, former Keeper of Archaeology for Tyne and Wear and Director of Excavations at South Shields Roman fort

Katie Mountain, archaeologist, Pre-Construct Archaeology, Durham

Rachel Newman, Senior Executive Officer, Oxford Archaeology, Past President of the Cumberland and Westmorland Antiquarian and Archaeological Society

Jürgen Obmann, Bavarian state office for the preservation of monuments

Kathleen O'Donnell, CFA Archaeology

Don O'Meara, Historic England, editor of *Archaeologia Aeliana*

David Petts, Associate Professor, Department of Archaeology, Durham University

Iwan Peverett, New Visions Heritage Ltd

John S. Poulter, independent researcher

Elsa Price, Curator of Human History, Tullie House Museum and Art Gallery, Carlisle

Ivana Protić, independent researcher

Carole Raddato, independent researcher

Mark Richards, author of Cicerone's guide Walking Hadrian's Wall Path and other guide-books for walkers

Tanja Romankiewicz, Chancellor's Fellow and lecturer in Archaeology, Edinburgh University

Alan Rushworth, The Archaeological Practice, Newcastle

Pete Savin, independent researcher

John Scott, co-ordinator, Hadrian's Wall World Heritage Site

William D. Shannon, Vice-President of the Cumberland and Westmorland Antiquarian and Archaeological Society

James Silvester, photographer

Avril Sinclair, retired schoolteacher

Martha Lovell Stewart, postgraduate student, Durham University

Rory Stewart, politician and author

Matt Symonds, editor, Current World Archaeology

Graeme Stobbs, formerly archaeologist, Tyne & Wear Archives & Museums

Catherine Teitz, The Vindolanda Trust

Andreas Thiel, Chief Conservator, State Office for the Preservation of Monuments, Stuttgart, Germany; co-chair of the Congress of Roman Frontier Studies

Carol van Driel-Murray, former lecturer in archaeology, Leiden University, The Netherlands

Harry van Enckevort, retired archaeologist of the municipality of Nijmegen and now independent researcher

David Walsh, lecturer in Roman Archaeology, Newcastle University

Sue Ward, a retired journalist and now an amateur historian

Humphrey Welfare, Visiting Fellow in Archaeology, Newcastle University

Alan Whitworth, retired English Heritage Hadrian`s Wall Recording Archaeologist

John Peter Wild, Honorary Research Fellow, Manchester University

Tony Wilmott, Senior Archaeologist, Historic England

John Wilkes, Professor Emeritus, London University

Alan Wilkins, specialist in Roman artillery

Pete Wilson, Rarey Archaeology, Weaverthorpe, Malton, Yorkshire

Rob Witcher, Associate Professor, Durham University